Marcel Paquet

RENÉ MAGRITTE

1898 – 1967

Thought rendered visible

TASCHEN

KÖLN LONDON LOS ANGELES MADRID PARIS TOKYO

To stay informed about upcoming TASCHEN titles,
please request our magazine at www.taschen.com or write to
TASCHEN America, 6671 Sunset Boulevard, Suite 1508,
USA–Los Angeles, CA 90028, Fax: +1-323-463 4442.
We will be happy to send you a free copy of our magazine
which is filled with information about all of our books.

© 2000 Benedikt Taschen Verlag GmbH
Hohenzollernring 53, D–50672 Köln
www.taschen.com
© 1992 VG Bild-Kunst, Bonn
Concept: Gilles Néret, Paris
Cover design: Catinka Keul, Angelika Taschen, Cologne
English translation: Michael Claridge, Bamberg
Composition: Utesch Satztechik GmbH, Hamburg

Printed in Germany
ISBN 3-8228-6318-1

Contents

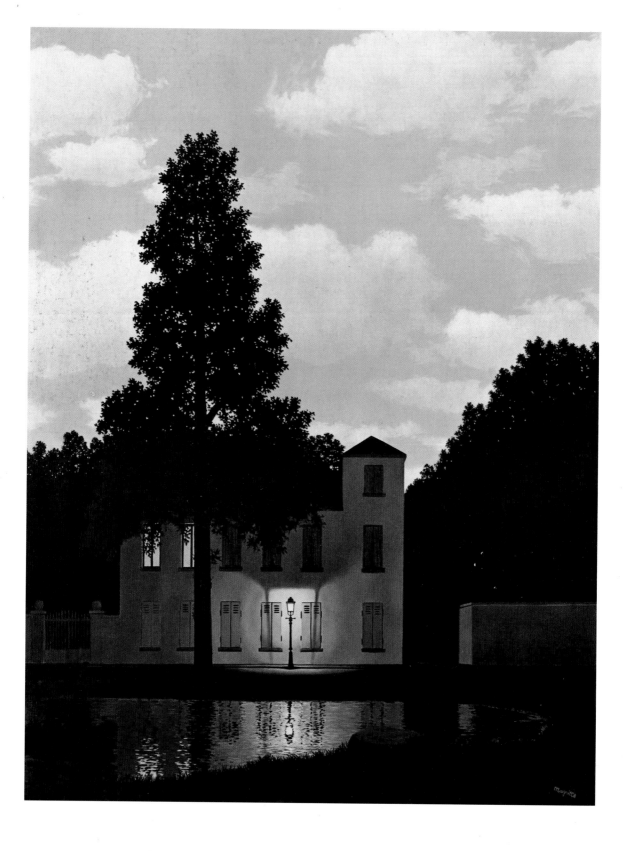

Growing up in the Black Country

René Magritte was born on 21st November, 1898, in a widely unrecognized country, namely in Belgium. The artificially constructed little state had been torn from time immemorial by conflict between its two ethnic groups, the Flemings in the north, speaking a dialect of Dutch and largely Catholic by denomination, and the Walloons in the south, always a bit rebellious and mostly of no one particular religious belief. The union of these two ethnic groups, with their so utterly incompatible mentalities, made it necessary to constantly reach laborious comprises, leading to legal and administrative complications of such a nature that they tended more to deepen the quarrels than to settle them. Foreign observers inevitably gained the impression that this was a state with a character all its own, a "Surrealist" character. This is the reason for the exceptional nature of "Belgian culture", in which systematic self-contempt and regionalist arrogance form curious combinations.

Magritte was born in the southern part of the country, spending his childhood and youth in Charleroi, an industrial city where life was very hard. His whole life through, the quiet, seemingly rather timid man was to hold political views of a left-wing persuasion. After the First World War, he was among those in Belgium propagating the ideas of the Dadaist movement. Together with E. L. T. Mesens, the poet and collage artist, he edited the magazines *Œsophage* and *Marie*, to which Arp, Picabia, Schwitters, Tzara and Man Ray also contributed. After the Second World War, he joined the Communist Party – for the third time – and wrote provocatively in its press organ, *Le Drapeau Rouge*, of the exhibition of work by James Ensor: "Finally, the interest shown by the visitors to the Ensor retrospective should be noted. They wander up and down in severe solemnity before the vegetables, the flower vases, the drunken Christ figures and all the other subjects which Ensor amused himself with painting, unaware that this seriousness which they are displaying is slightly out of place. If it were possible to forget all the gossip and the legends which so misrepresent James Ensor, then a large exhibition of his work such as this would perhaps throw a little light upon the artistic atmosphere which is still in a state of some obscurity due to the period of Nazi rule. It would appear, however, that we must needs still live with this state of obscurity."

Magritte's political involvement was based essentially upon his spirit of opposition. All of his poster designs were rejected on principle by the party leadership, and he could not bear having to subordinate his art to an ideological party line, even one so broadly conceived. "There is no more reason for art to be Walloon than for it to be vegetarian", was his reply to those seeking to enlist him for exhibitions aimed at demonstrating region-

René Magritte alongside his painting
The Empire of Lights, 1954

The Empire of Lights, 1954
A nocturnal scene under a daytime sky. It is only at second glance that one becomes aware of the surreal nature of this apparently so true-to-life scene. Magritte interpreted it as follows: "I have reproduced different concepts in *The Empire of Lights*, namely a nocturnal landscape and a sky as we see it during the daytime. The landscape leads us to think of night, the sky of day. In my opinion, this simultaneity of day and night has the power to surprise and to charm. This power I call poetry."

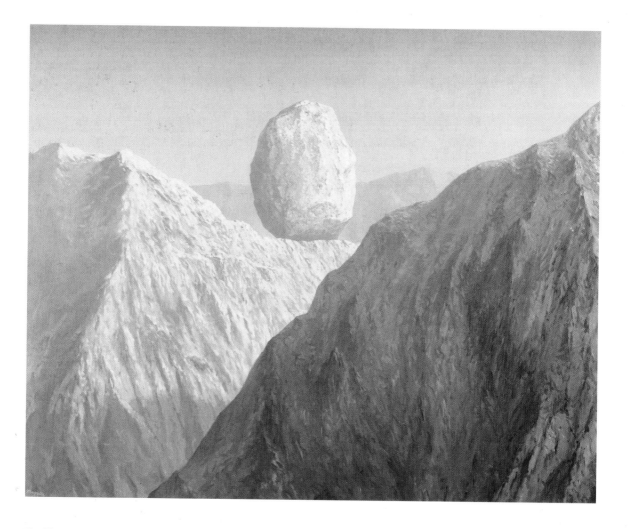

The Glass Key, 1959
"I think that the best title for a picture is a poetic title." René Magritte

As in his pictures – here, for example, the rock seemingly hanging motionless in mid-air – Magritte likewise frequently sought fantastic, "poetic" motifs for his titles.

alist interests. Ultimately, his sole, his real banner was the mystery inherent in objects, in the world, that mystery which belongs to everyone and to no one.

Magritte apparently retained few memories of his childhood in the province of Hainaut, where his parents' house in Lessines is today a little museum containing various documents. His memories were all the more vivid for being so few, however. His earliest recollection concerned a crate next to his cradle; it struck him as a highly mysterious object, and aroused in him that feeling of strangeness and disquiet which he would encounter again and again later in his adult life. His second recollection was connected with a captive balloon which had landed on the roof of his parents' house. The manœuvres undertaken by the men in their efforts to fetch down the enormous, empty bag, together with the leather clothing of the "aeronauts" and their earflap helmets, left him with a deep sensitivity for everything eluding immediate comprehension.

Magritte himself speaks of the third and last childhood recollection, with which we will concern ourselves here, in a lecture given in 1938: "During my childhood, I liked to play with a little girl in the abandoned old cemetery of a country town... We used to lift up the iron

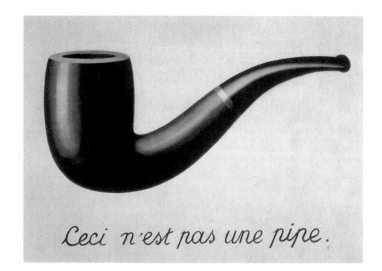

The Treachery of Images, 1928/29
"The famous pipe…? I've been reproached
enough about it! And yet… can you fill it?
No, it's only a depiction, isn't it. If I had writ-
ten 'This is a pipe' under my picture, I would
have been lying!" René Magritte

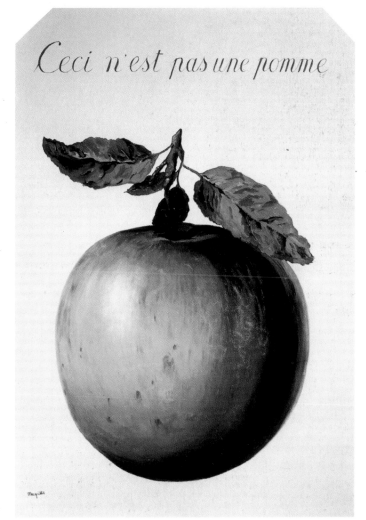

This is not an Apple, 1964
The apple, be it painted in never so illusionary
and tempting a manner, remains no more than
paint on a ground. Nor does the word "apple"
constitute the fruit itself, but is merely a de-
scription that is ultimately arbitrary in nature.

The Bather, 1925
The graphic structure of the composition, using simple, clearly outlined forms, and largely abstaining from depicting spatial depth, calls to mind the ornamentation and posters of Art Déco.

René, Raymond and Paul Magritte, 1907

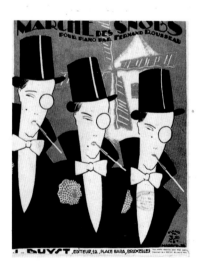

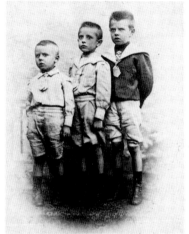

Marché des Snobs, 1924
Cover of a musical score

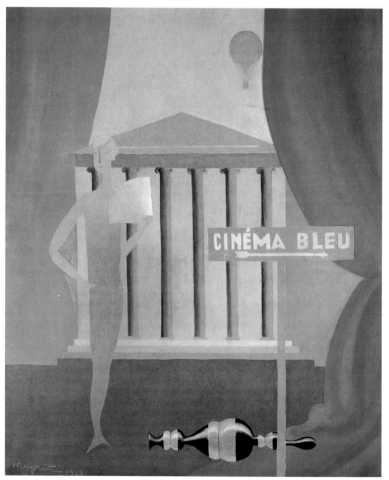

The Blue Cinema, 1925
Magritte's brother Paul was a composer. Both of them loved the cinema, especially the exploits of Fantômas, the criminal without identity.

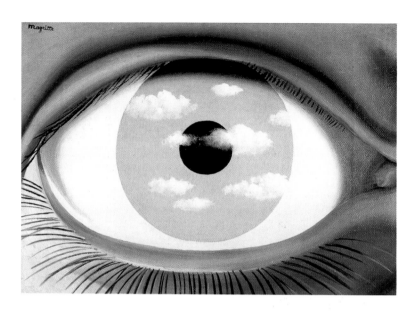

The False Mirror, 1935

"The eye is the mirror of the soul within", according to one version of the proverb. Magritte is playing his game of reversal again here, one of questioning what is outside, what inside. The overdimensional human eye, instead of providing a view into what lies within, into man's soul, reflects what lies without, namely a sky with clouds in it.

gates and go down into the underground vaults. Once, on regaining the light of day, I noticed an artist painting in an avenue of the cemetery, which was very picturesque with its broken columns of stone and its heaped-up leaves. He had come from the capital; his art seemed to me to be magic, and he himself endowed with powers from above. Unfortunately, I learnt later that painting bears very little direct relation to life, and that every effort to free oneself has always been derided by the public. Millet's *Angelus* was a scandal in his day, the painter being accused of insulting the peasants by portraying them in such a manner. People wanted to destroy Manet's *Olympia,* and the critics charged the painter with showing women cut into pieces, because he had depicted only the upper part of the body of a woman standing behind the bar, the lower part being hidden by the bar itself. In Courbet's day, it was generally agreed that he had very poor taste in so conspicuously displaying his false talent. I also saw that there were endless examples of this nature and that they extended over every area of thought. As regards the artists themselves, most of them gave up their freedom quite lightly, placing their art at the service of someone or something. As a rule, their concerns and their ambitions are those of any old careerist. I thus acquired a total distrust of art and artists, whether they were officially recognized or were endeavouring to become so, and I felt that I had nothing in common with this guild. I had a point of reference which held me elsewhere, namely that magic within art which I had encountered as a child.

In 1915 I attempted to regain that position which would enable me to see the world in a different way to the one which people were seeking to impose upon me. I possessed some technical skill in the art of painting, and in my isolation I undertook experiments that were consciously different from everything that I knew in painting. I experienced the pleasure of freedom in painting the most unconventional pictures. By a strange coincidence, perhaps out of pity and probably as a joke, I was given a catalogue with illustrations from an exhibition of Futurist painting. I now had before my eyes a mighty challenge directed towards that same good

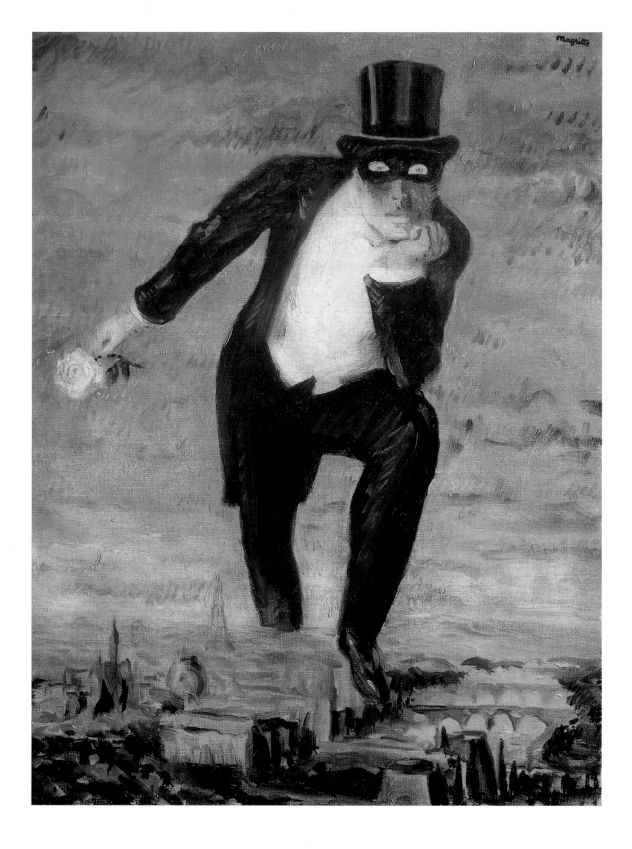

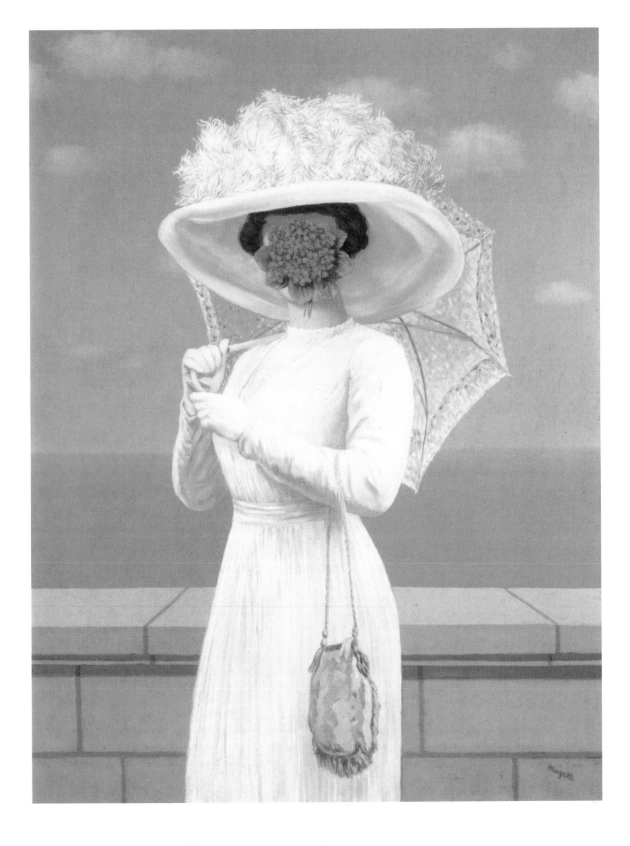

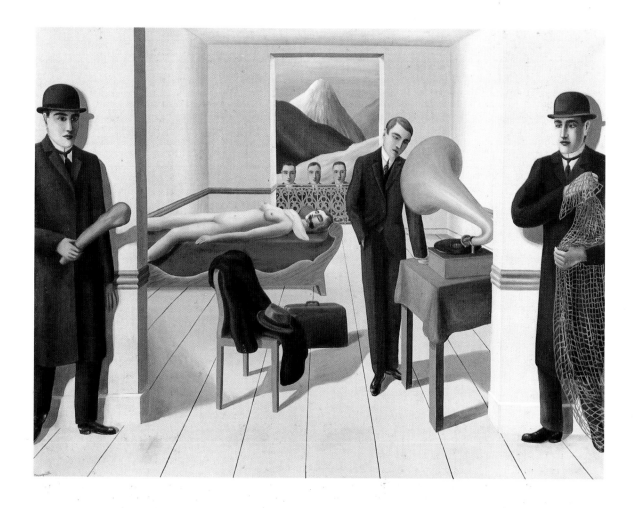

The Threatened Assassin, 1926
He has turned his back upon those watching him, nor does he notice those seeking to overcome and apprehend him. He is observing musical sounds. He is functioning in another way, conducting himself with indifference towards the obvious threat posed by reality.

ILLUSTRATION PAGE 12:
The Return of the Flame, 1943
Mystery lives under the visible reality of the world. Here it is manifesting itself in the form of Fantômas, assuming control.

ILLUSTRATION PAGE 13:
The Great War, 1964
"Every single thing which we see conceals something else; we would dearly love to see what that which we can see is hiding from us…"
René Magritte

sense which so bored me. It was for me the same light that I had encountered as a child whenever I emerged from the underground vaults of the old cemetery where I spent my holidays."

In retrospect, the image of the little girl and little boy climbing out of an underground vault in which death is present, and then discovering a painter who is attempting to record his view of the cemetery on canvas, seems almost an advance announcement of Magritte's later career. The artist's childhood, and the dreams bound up with it, should not of course be regarded as the sole veritable key that enables us to gain access to the mysteries of creative output. It is clear that such pictures from the depths of the past cannot play a role in the creation of a work of art until they have been reappraised and reinvented with the help of and as a consequence of decisions taken, encounters made and coincidences experienced by the meanwhile mature artist. Given Magritte's concern to record in written form precisely this recollection, however, it is fair to assume that it contains elements which – in the manner of a kind of educative experience – serve to introduce us to the imaginary world of his work. The record of his childhood experience specifically mentions the sharp contrast between the view of the two children, who are in principle as far away as can be from the end of

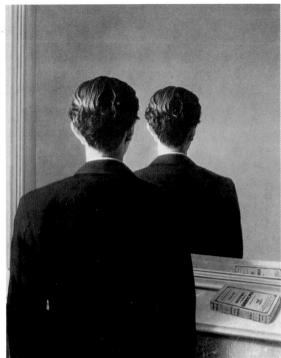

life, and the place where they are playing. A cemetery is the place *par excellence* in which one's memories of those no longer with us are preserved and cherished. It soon becomes clear that elements almost always appear in Magritte's pictures such as present a sharp contrast to each other, thereby triggering a shock which shakes the intellect out of its apathy and sets one to thinking. The simultaneity of day and night in his picture *The Empire of Lights* (ill. p.6), probably his most famous work, makes this clear.

This painting owes its title to Paul Nougé, the poet. It should be pointed out, however – and in contrast to the obstinately persistent legend – that it was extremely rare for Magritte's pictures to be given their titles by others. While it is true that the artist loved to gather with friends in front of his completed pictures and enjoyed finding titles for these works in their company, we know of only a few examples indicating his actually taking up their suggestions: Georgette, his wife, tells us how "It often happened that, come the next day, he was no longer satisfied with their inventions, and would then choose a name with which he himself was happy." This is the case with *Hegel's Holiday* (ill. p.30), for instance. The picture portrays an object whose function is to repel water – an umbrella – juxtaposed with an object which contains water – a glass. We should probably talk here not so much of a contradiction as of a contrast, since the idea behind the picture is not very profound. And indeed, it is for this reason that Hegel is on holiday, going without the rigorousness of logical demonstrations so as to devote himself to pictures of an entertaining nature.

A different contrast predominates in the picture of a rock hanging motionless in the air, a contrast between the weight of the stone and the lightness attributed it by the painting. Magritte characterizes one impossibility

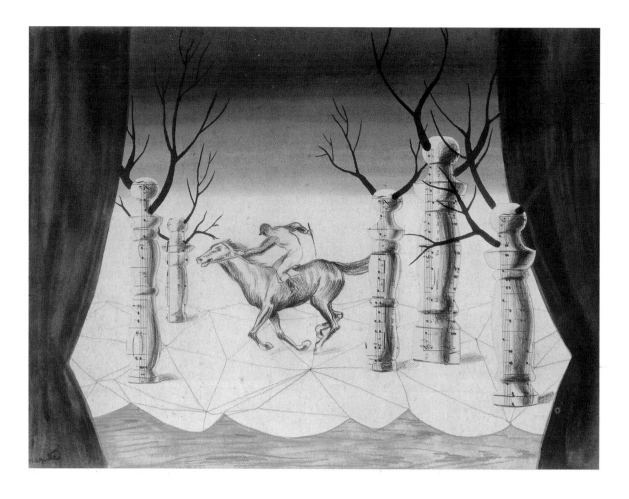

The Lost Jockey, 1926
The jockey is lost in an unreal world, between tree-figures inscribed with musical notation. The scene is taking place on a theatre stage framed by curtains. This picture is considered to be Magritte's first "Surrealist" work.

by means of another, as in the picture *The Glass Key* (ill. p. 8); at the same time, he is following a process which he would often employ in order to pay homage to one of his favourite authors, Dashiel Hammet. In this case, the contrast exists not between different objects but rather between the different qualities of the same object: the weight of the stone cannot be reconciled with the lightness which the painted picture gives it. Depending upon the mood of the artist, reality can be changed and given a different manifestation in the picture; similarly, the artist can give things a logic such as contradicts the laws of common perception. Magritte played ceaselessly with this possibility of diverging from reality, with this unreality within art: one cannot smoke the depiction of a pipe (*The Treachery of Images*, ill. p. 9), nor can one make love to a canvas (*Black Magic*, ill. p. 28).

The picture of *The Lost Jockey* (ill. p. 16) from 1926 is the first work to which Magritte himself allowed the label "Surrealist" to be applied. However, there had already been initial signs beforehand heralding the artistic process for which he would later become famous. We will return to this later. The well-known *bilboquets*, for example, a form of baluster or oversize playing piece to which Max Ernst gave the beautiful, vivid name of "phallustrade", turn up again in the portrait of *Georgette with Bilboquet* (ill. p. 15), while the picture *The Bather* (ill. p. 10) clearly demon-

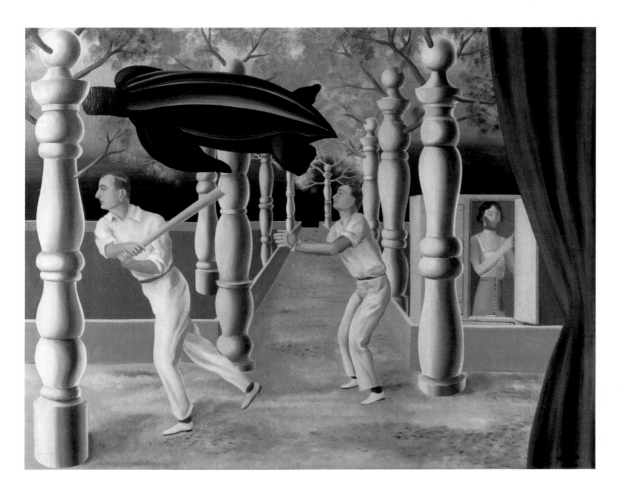

The Secret Player, 1927
The scenery here is similar in its stagelike quality to that in *The Lost Jockey*; here, however, two men dressed in white are playing some mysterious, apparently serious game.

strates that Magritte had abandoned the Cubist technique in favour of a manner of creating pictures that was already fully Surrealist. He continued working on his pictorial discoveries until 1967, the year of his death, leaving an unfinished painting. As far as we know, the work had been commissioned by a young German collector from Cologne, who wanted "something in the nature of" *The Empire of Lights* (ill. p.6); he was destined never to take possession of the picture he had ordered. The uncompleted painting would remain on its easel in the painter's house in Brussels until the death of Georgette Magritte in 1986.

We may recall that the cemetery where the eight-year-old Magritte played with a little girl and where his erotic sensibility was aroused also constituted the workplace of a painter, a being with magical powers by means of which he could imitate reality while simultaneously portraying this reality quite calmly in an unfaithful manner – painting daytime by night; painting a bird from a model in front of him, despite his model being no more than an egg (*Perspicacity*, ill. p.24), or a mirror in which is reflected the back of the individual facing it (*Not To Be Reproduced*, ill. p.15). We are concerned here with a recollection which announces something with great clarity: a jarring contrast, such as that of "developing life" and "bygone life", is brought together by means of a creative ability that illustrates this contrast, rendering it visible via the

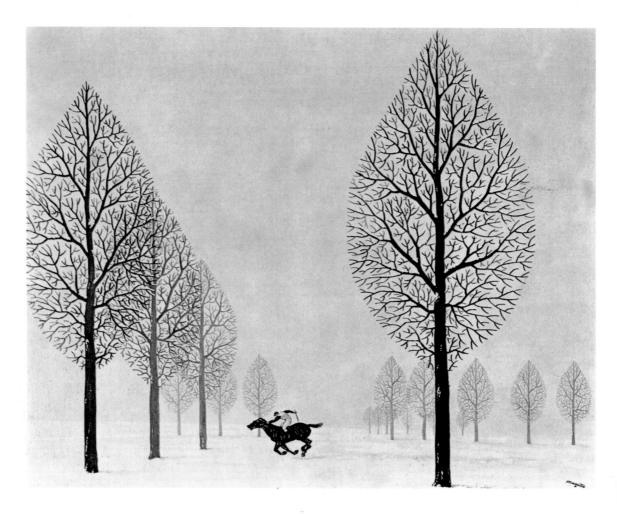

The Lost Jockey, 1948
The picture represents a purified, simplified return to the 1926 work. The surreal element has been achieved here through much more economical means. The trees appear like sketched leaves, or nerve tracts.

painted picture. The essential components of Magritte's work are contained in this early recollection, albeit separated or at least differentiated: there are the children and their first erotic feelings, on the one hand, and the act of painting on the other. It is within the systematic combining of contrasts, in meaningful associations, in the association of thoughts – in short, with the power of free disposition inherent in the act of painting – that the intellectual fusion of the two sources of power takes place such as must occur in order that they may find their way with Magritte into the strange *Enchanted Realm* (ill. pp.32/33). It is of course true that this freedom in painting with respect to its models is not the bequest of Magritte alone. What is specifically Magritte is the carefully considered, balanced, austere and consciously academic manner so characteristic of his work. He left pictures which are also polished in the technical sense; the way in which he employs the colour blue is the equal of Degouve de Nuncques in every respect. The charms of his so-called Impressionist (or "Renoir") period, or his "en plein soleil" phase, are also well known; Magritte was seeking through this phase to communicate to people towards the end of the war the confidence which they so badly needed (*Favourable Omens*, ill. p.25). In order that he might achieve this, he was prepared to fundamentally alter

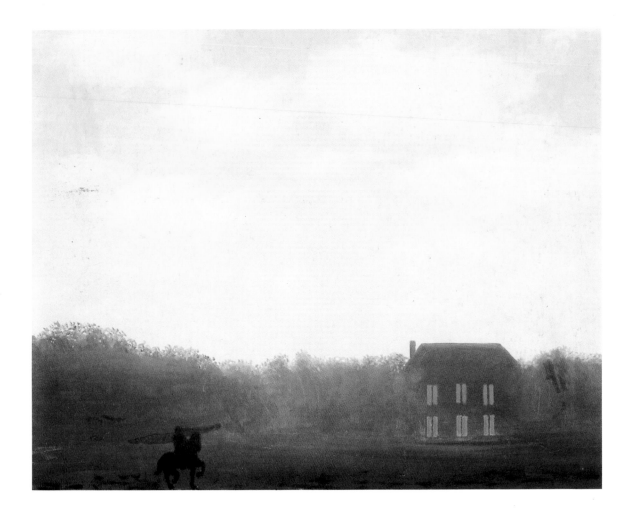

his palette. However, the essential elements of his work should be sought elsewhere.

Magritte was primarily a painter of ideas, a painter of visible thoughts, rather than of subjects. He valued neither lyrical nor Expressionist abstraction. In his view, those artists producing such work, in presenting subject-matter, were presenting nothing worthy of a single thought, nor even deserving of one's interest. Magritte did not possess a studio in the strict sense of the word, responding maliciously to those who commented in surprise upon this that painting was done in order that it might land on the canvas, and not on the carpet, which indeed revealed not the slightest stain. The truth is that we cannot even say with any certainty whether Magritte actually enjoyed painting. He clearly liked to think in pictures; as soon as he had elaborated these thoughts with the aid of sketches and little drawings, however, he baulked at the idea of transferring them onto canvas, preferring to go and play chess in the "Greenwich", a well-known Brussels café. He was not as passionate a player as Man Ray or even Marcel Duchamp (who was infuriated at losing twice in a row to an eleven-year-old boy named Fischer); nevertheless, Magritte loved this form of visible mathematics more than the act of painting. Numerous anecdotes attest to his great con-

The Empire of Lights (unfinished), 1967
This return to *The Empire of Lights* – Magritte died before he could finish the picture – renders the mystery of things as if turned to stone. The light emanating from the interior of the house keeps its secret for ever.

In Praise of Dialectics, 1936
"An interior with no exterior could itself
hardly constitute an interior." G. F. Hegel

Magritte's most frequent concern in selecting
his motifs is the inversion or fusing of interior
and exterior views, or of opposites or extreme
positions, to put it in more general terms.

tempt for that which Bram Bogart called "peinture-peinture" (which
may be roughly translated as "painting pretty pictures") and Marcel Du-
champ the class of the "rétiniens" ("retina-cretinas") – in contrast to
the class of the "grey subject-matter".

One day, Magritte let himself be persuaded by Georgette and a couple
with whom they were friends to undertake a trip to Holland to visit an ex-
hibition on Frans Hals, possibly the greatest master of using black in
painting. Upon arriving in front of the museum, Magritte informed the
others that Loulou, his little dog, did not want to see Frans Hals. And so,
while his wife and their friends went round the exhibition, he waited for
them in a little café, getting drunk on advocaat, an extremely sweet, egg-
based alcoholic drink which rapidly makes one feel nauseous. He loathed
so-called cultural trips. His laconic comment, upon seeing the pyramid of
Cheops at Gizeh: "Yes... much as I expected." In the same way, he fre-
quently repeated that the reproduction of a painting was all that he
wanted, that he needed to see the original exactly as little as he had to
read the original manuscript of books which he had read. The legacy of
Dada in such jokes is unmistakable.

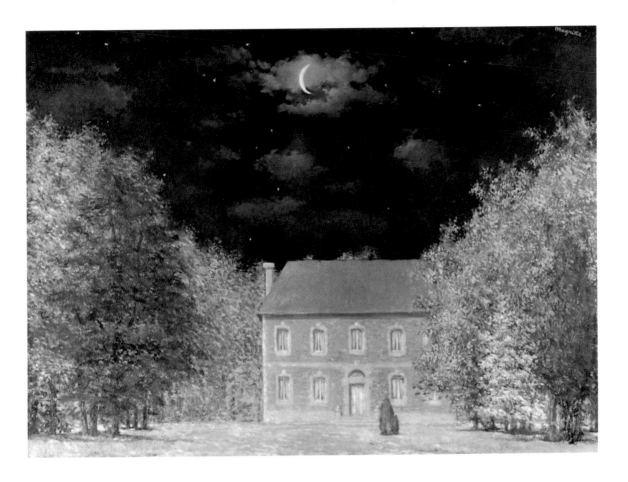

God's Salon, 1948
"I can imagine a sunny landscape under a night sky; only a god is capable of visualizing it and conveying it through the medium of paint, however. In the expectation that I will become one, I am dropping the project..."
René Magritte

Nor is there any question that Magritte felt more indebted to the spirit of objects à la Marcel Duchamp than to the spirit of the *Woods* by his friend Max Ernst, for example, for whom he painted *The Nightingale* (ill. p. 22). It is important to underline the considerable emphasis of the intellectual, reason-orientated, reflective starting-point behind this artist's work, painting for philosophers or at least for lovers of philosophical thought. In Magritte's art, the poetic shock, the aesthetic stimulation prompted by the picture, most definitely should not be separated from a love of thinking, an unrestrained pleasure in reflection and nimbleness of mind. *The Hereafter* (ill. p. 31) is accordingly presented as a simple tomb without any form of inscription, a highly ironic way of reminding the observer that there is no life without body and flesh, without the senses, without sight. Life only exists when it is tangible, and art only exists as something visible; that which one can recognize beyond it is not its essential being, not its invisible essence, but at best an object, one indicating the boundary of what is visible from within, through its contours, and thereby an insurmountable barrier. One cannot go beyond a stone tomb; it is absolutely final, closed in upon itself. The most that it can do is to

evoke *Memory* (ill. p. 30). And it is surely hard to imagine memory better, or render it more visible, than in the face of a young woman chiselled into the stone, a woman of whom it is known that she no longer exists, that she once lived, that she will never more be, a woman with a blood-stain on her temple which refers expressively to her former existence, one for ever gone.

The Rape (ill. p. 29), one of Surrealism's most powerful images – Georges Bataille could never suppress a nervous laugh whenever he was confronted by this painting – likewise works with a subversive idea. The breasts constitute the eyes, the navel the nose, the pubis the mouth. So composed, the face reflects the secret desires of the painter and the observer that some women can convey their sexuality in the way in which they look at one. Painting, the art of rendering things visible, reveals its ability here to record impressively the constant sex-appeal which leaves its mark upon almost every moment of our lives. The selection of the work's title indicates the ongoing conflict of the voyeuristic observer; Magritte comes very close here to Hans Bellmer's erotic perversion, albeit without the latter's sadness. He has destroyed what is most obvious of all, namely the face, replacing it with some-thing even more obvious. It is the shock effect of the picture *together with* the basic idea lying behind it, the simple *together with* the reflected view, the sight *together with* the sight of the sight, which represent the key components of his work, those two fundamental demands which he was ever formulating anew. Magritte is subversively turning customary perception inside out: the objects which he paints are all clearly recog-nizable, come from the banal and everyday sphere, yet as soon as they are painted in a highly academic fashion, like a primary-school lesson in general knowledge, they change, and everything is plunged into un-certainty. Magritte is presenting things here according to a poetic logic, a set of rules such as depicts them in a completely new light, furnishing them with a totally new power.

The artist is making free in a provocative and bewildering manner with the world of appearances. By placing in a birdcage not the bird itself but an egg of excessive proportions (*Elective Affinities*, ill. p. 26), he dem-onstrates the foolish cruelty of humans, constantly interested only in dominating others, in locking others up, in keeping the various forms of life under their control. In showing us a lion on a bridge, where it surely has no business to be, and a man next to it with folded wings, seemingly dreaming in melancholy manner of going away, of fleeing, even of dying – longing, at any rate, to escape from the prison that this world represents – in depicting all this, is the painter not referring to *Homesickness* (ill. p. 27), the bitter dream of a much longed-for but unattainable other place? Magritte – wise, level-headed, reserved and living almost in anonymity – was incensed by the stupidity and downright nastiness of mankind, by the baseness and vulgarity of modern life.

"I'm no 'militant'", he said to Patrick Waldberg in 1965. "I feel un-armed for a political struggle, both as regards my competence and with respect to my energy. However, I hold to what you say I am, I continue to be *for* 'socialism'...that is, a system which does away with the inequality of property distribution, with differences, with war. In what form? I don't know, but that's my attitude, despite every defeat and set-back."

Magritte's father was a tailor and merchant, his mother a milliner, and business was bad. His childhood consisted of one move after another: Lessines, Gilly, Châtelet, Charleroi, Châtelet, and Charleroi again, where

Study for: *The Nightingale*, 1962

ILLUSTRATION PAGE 22:
The Nightingale, 1962
In French, the term "nightingale" (*rossignol*) is used to describe a piece of junk, one not worth its retail price. The nightingale's song can also distantly call to mind the rhythmic hissing of a steam engine, however. For his part, Magritte rejects such direct explanatory interpretations: "The pictures' titles do not constitute explanations; nor do the pictures il-lustrate their titles. The relationship between title and picture is a poetic one: this relation-ship serves merely to record certain character-istics of the objects such as are commonly ig-nored by one's consciousness but of which one sometimes has a presentiment when con-fronted by extraordinary events which one's reason has by no means been able to shed light upon yet."

23

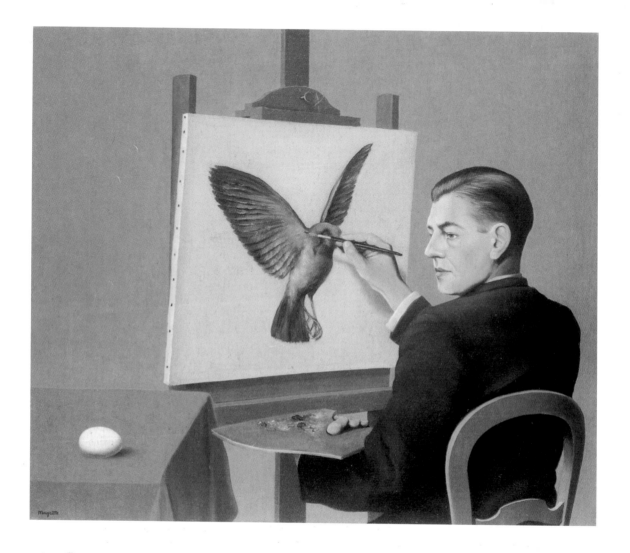

Perspicacity, 1936
Magritte depicts himself here in his occupation as a painter. More than this, he conveys the idea of the mental process inherent in this artistic craft: the egg forms the motif, yet, translated by the artist, its manifestation on the canvas takes the form of a bird.

he was finally taken into the care of nannies and his grandmother following the dreadful suicide of his mother, Regina, née Bertinchamps, who had thrown herself into the dark waters of the River Sambre for reasons which remained unclear. René was fourteen years old at the time. The incident was described much later by Louis Scutenaire in words which – according to Georgette, whom the present writer knew well and often talked to concerning this subject – almost stylized the whole episode into a legend. The only recollection which Magritte himself admitted to having of the affair was that of a feeling of pride at suddenly finding himself the focal point of interest and sympathy both in the neighbourhood and among his fellow pupils at the Charleroi grammar school. It is certain that he never saw his mother's corpse, "its face covered with a nightdress". The absurd psychological interpretations of his work undertaken by the likes of David Sylvester are quite untenable. For the sake of clarity, it should be stressed that it is the literary, intellectual and philosophical elements which must be followed up if one is to even approach an understanding of this artist's extraordinary work.

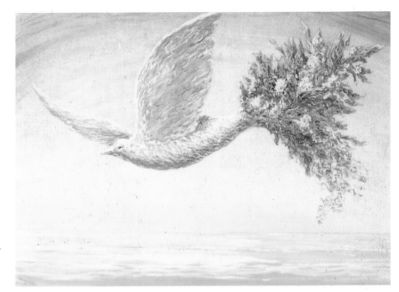

Favourable Omens, 1944
The dove of peace and flowers of the "Plein soleil" period, the latter painted in vivid colours, should be interpreted as Magritte's anticipation of the approaching end to the Second World War. This work was a present for Georgette's sister.

Magritte working on his painting *Perspicacity*, 1936. – Double self-portrait.

"Psychoanalysis has nothing to say, not even about works of art, which evoke the mystery of the world. Perhaps psychoanalysis itself represents the best case for psychoanalysis." Magritte regarded it as a pseudo-science of the unconscious, a criminological and ideological starting point. As Michel Foucault – with whom Magritte had an interesting and instructive correspondence – succinctly explained, psychoanalysis aims at finally confirming existential repression by restricting desire to the family triangle, to the legally legitimized married couple. In psychoanalysis, love always means Daddy, Mummy and me! Magritte was a Surrealist from the depths of his being through his sense of *amour fou*, once writing: "Happy is he who betrays his own convictions for the love of a woman." He opposed Freud's theses, automatist experiences based upon the power of the unconscious, and everything that all too often in the circle around André Breton, the artist, threatened to become dogma and law. It was unavoidable that those artists who were obviously permeated by Surrealism would be excluded sooner or later from the Surrealist movement. André Masson had realized this, and himself demanded his own exclusion. Breton's reply to this was remarkable: "Why? I have never exerted any pressure upon you." "Proof", retorted Masson, "that you have exerted it upon others." Magritte, for his part, to whom Breton had written indignantly, "Your dialectics and your Surrealism *en plein soleil* are threadbare", answered, "Sorry, Breton, but the invisible thread is on your bobbin."

It would be possible to mention further anecdotes in this context; however, this would only do harm to the deep unanimity which served to weld together this little group of inspired people despite their various divergences, childish acts and comments.

One evening, when Georgette and René Magritte were in a taxi with Paul Eluard on their way to a meeting of the Surrealist group, Eluard drew Georgette's attention to the small golden cross which she was wearing around her neck, advising her to hide it since Breton would be sure to take offence at it. She refused, and "The Pope" indeed made reference to

25

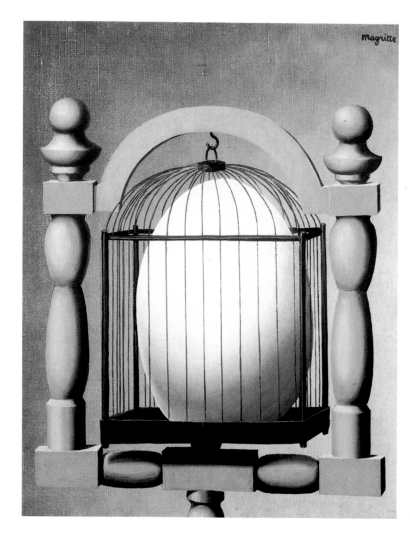

LEFT:
Elective Affinities, 1933
"One night, I woke up in a room in which a cage with a bird sleeping in it had been placed. A magnificent error caused me to see an egg in the cage, instead of the vanished bird. I then grasped a new and astonishing poetic secret, for the shock which I experienced had been provoked precisely by the affinity of two objects – the cage and the egg – to each other, whereas previously this shock had been caused by my bringing together two objects that were unrelated." René Magritte

RIGHT:
Georgette and René Magritte, 192?

the un-Surrealist character of the object, prompting Magritte to decide that he and his wife would forthwith stay away from these meetings. The whole affair had blown over by the next day, however, and the Magrittes continued to attend the gatherings, along with Breton, Dalí, Miró, Max Ernst and the others, while Georgette went on wearing the keepsake from her mother around her neck. With regard to relations within the group, persistent legends occasionally have a tendency to magnify small, harmless disagreements out of all proportion. The only thing of importance here is that Magritte's work is decisively Surrealist. Like many others, he was disturbed by Breton's doctrinaire attitude; however, this had no influence upon his painting. In Magritte's case, Surrealism results from the unfaithfulness of the reflection presented in the picture: the view of the painter, the view emerging from the depths of perception, is a *False Mirror* (ill. p. 11). The painter's eye betrays what it is regarding; it is a mirror revealing the mystery in things which they otherwise conceal, one which can only be uncovered through the intervention of art and the intellect.

René Magritte had two brothers, Paul and Raymond (photograph

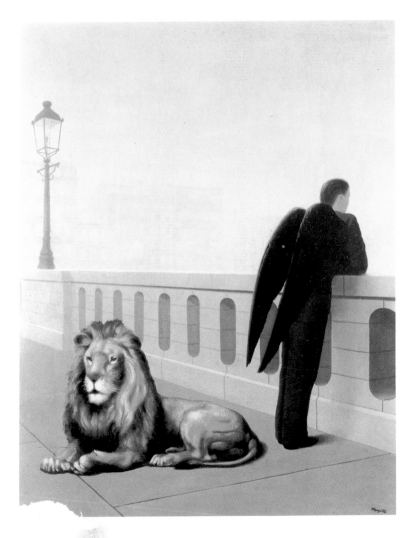

Homesickness, 1940
Neither the lion nor the man with folded wings have any business being on this bridge. They embody the melancholy of those who know that real life is always something else, something that does not exist.

Georgette with Loulou, her white dog

p. 10), both somewhat younger than himself. Raymond, the youngest, was a clever businessman with a practical and realistic intellect; art and poetry meant nothing to him. Even after his brother's first great successes, Raymond continued to regard him as an idiot and a "nut-case". It is true that Magritte demonstrated something of an antisocial tendency; with his rebellious temperament, he found it difficult to conform to existing conventions. One day, the King wished to give a banquet in his honour, perhaps intending to commission a picture from him; Magritte rang up the master of ceremonies a few hours before the dinner was due to begin, informing him that he had unfortunately burnt a hole in his dinner jacket with his cigarette, and would therefore be unable to participate in the festivities. He soon fell out with Raymond, whom he criticized for being bourgeois and conformist; on the other hand, he always felt very close to his other brother. Paul wrote popular songs, composing "Le petit nid", "Quand je t'ai donné mon cœur", and arranging two works by Georgius, "J'aime ma maison" and "Je suis blasé". He also composed the music for a poem by Paul Colinet, "Marie trombone chapeau buse", a

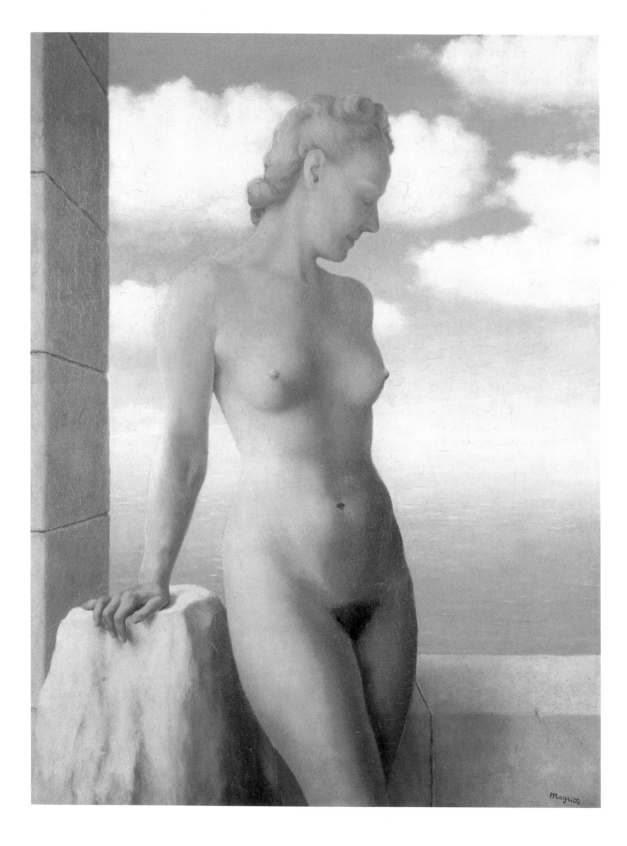

minor masterpiece every bit the equal of Satie and Fargue. Paul and René often joined forces against Raymond during their childhood; they were both extremely interested in the love affairs of their father, who knew only too well how to console himself as a widower. They also shared a boundless love for the pleasures of the cinema, avidly following the famous Fantômas series in 1913 and 1914, which had been inspired by the novel by Souvestre and Allain. Their Thursdays and Sundays were filled with the heroic deeds of this enigmatic being. Fantômas was a sinister hero without identity, totally criminal but highly popular, who in some enviable way had succeeded in becoming revered precisely because of his disgraceful deeds. There can be no doubt that this mysterious challenge to the established order and the laws of the ruling class represented a rich source of inspiration for Magritte, one which also played a role in the subject matter of some of his pictures: one thinks, for example, of such pictures as *The Return of the Flame* (ill. p. 12) or *The Threatened Assassin* (ill. p. 14).

The influence of the Fantômas figure also played a significant role in Magritte's selection of titles for his pictures. Patrick Waldberg has been able to provide evidence of the considerable importance of the titles of Magritte's pictures within his work as a whole, where their purpose may be seen as providing a counterpoint to realistic perception. For instance, the woman in the feathered hat, her face hidden by a bunch of violets, should be seen as *The Great War* (ill. p. 13), as an incessant conflict with that which is visible, where each object always hides another. In revealing itself, an object simultaneously conceals itself, thereby functioning as the curtain for another. Magritte was always deeply conscious of this tightrope walk between revelation and masking. Things have a flip side, a reverse, which is even more curious and fascinating than their manifested form, the façade presented to everyone, their face; and it was this reverse, this dark side, which Magritte so subtly captured and rendered visible, in defiance of all logic. Accordingly, the titles of his pictures never serve to describe or identify. On the contrary, they bring some additional infringement, some further false trail, into play, the function of which is to create a confrontation within language and the logic of words, one analogous to the confrontation arising out of the painted picture. Magritte's work is certainly representational, and yet, at the same time, it constitutes an incessant attack upon the principle of reproduction in art. What his figures thereby lose in identity, they gain in mystery and otherness. Mystery finds its way into the everyday in Magritte's art, while subversive thought becomes gentle custom. Joy is constant; every moment is a festival.

The monotony of everyday life in Charleroi was interrupted not only by the pleasures of the cinema but also by the annual fair, which took place at the Place du Manège opposite the Musée des Beaux-Arts, in direct proximity to the Palais des Beaux-Arts, home of one of Magritte's most famous frescoes, *The Ignorant Fairy* (ill. pp. 32/33). The fair of 1913 was to confer a lustre upon his life for ever more. A merry-go-round salon stood between the stalls and various amusements, a fairground institution which is no longer to be found. After a turn on the wooden horses, the boys and girls would walk around hand in hand, to the strains of a Limonaire organ. This merry-go-round was among those places where boys and girls met to embark upon their first flirtations. Magritte, who was fifteen that year, invited a little girl not yet even thirteen to a round: Georgette. Her father was a butcher in Marcinelle. Love was

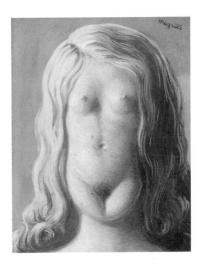

***The Rape*, 1948**
"In this painting, a woman's face is made up of the essential features of her body."
René Magritte

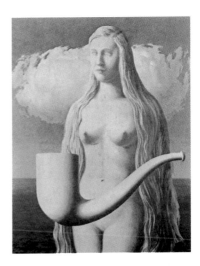

***The Mask of Lightning*, 1967**

ILLUSTRATION PAGE 28:
***Black Magic*, 1933/34**
"... The idea is that the stone is linked to the ground, remains firmly attached to it, cannot of itself move ... The stone's qualities, its clearly portrayed hardness – 'a hard feeling' – and the intellectual and physical qualities of a human being: seen from another point of view, they are not unrelated..."
René Magritte

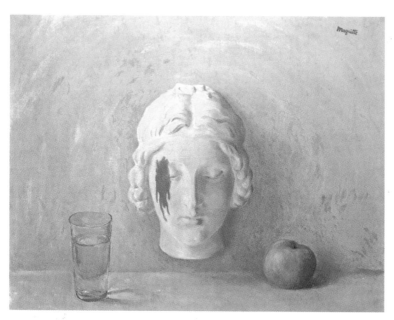

Memory, 1945
The work was directly inspired by Giorgio de Chirico and keeps in mind the silent life which still lifes negate.

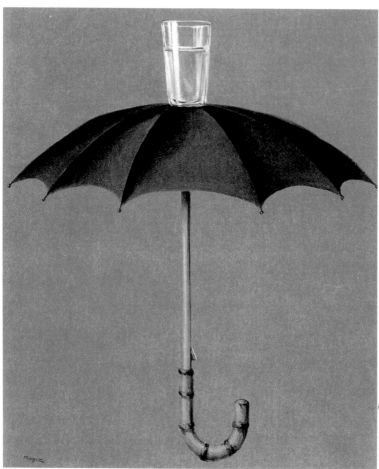

Hegel's Holiday, 1958
Hegel, the exponent of philosophical dialectics, is the inspiration behind this picture. Magritte sums up: "I ... thought that Hegel ... would have been very sensitive to this object which has two opposing functions: at the same time not to admit any water (repelling it) and to admit it (containing it). He would have been delighted, I think, or amused (as on a vacation) and I call the painting *Hegel's Holiday*."

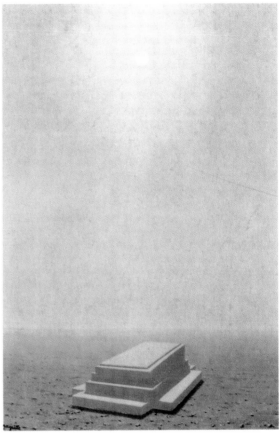

clearly already in the air at their first rendezvous: while life was to separate the two of them for some time, they would find each other again in the end, thereafter never to be parted. When, following the death of Georgette's mother, neither she nor – even more so – her older sister, Léontine, could bear the thought of their widowed father remarrying, the sisters left Charleroi and moved to Brussels. They found work in an arts and crafts co-operative near the Grande Place, and settled down in the capital. Léontine married Pierre Hoyer, the owner of a business; Georgette, after initially remaining alone, met her René again in 1920 while they both were walking in the Botanical Gardens (today the Maison de la Culture). The two stayed together, and Georgette became his sole model. They were married in 1922, a year which surely represented the most decisive in Magritte's entire life, not only for the artist himself but also for the direction taken by his work.

LEFT:
Study for: *The Hereafter*, 1938

RIGHT:
The Hereafter, 1938
According to Magritte, there is no "hereafter" in the sense of a life after death. The hereafter is the meditation on something final, on a tomb without inscription. The hereafter of painting is to be found in painting, in the same way as the perception of death is to be found in life.

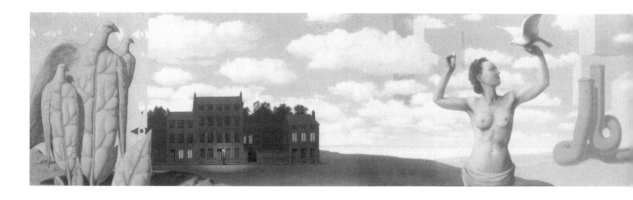

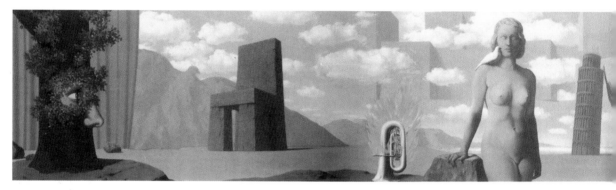

TOP AND CENTRE:

The Enchanted Realm, 1953
The figures and locations of Magritte's picture-world, his *Enchanted Realm*, appear here all in a row. While they belong together, each of them nonetheless seems completely self-sufficient, apparently preoccupied with itself.

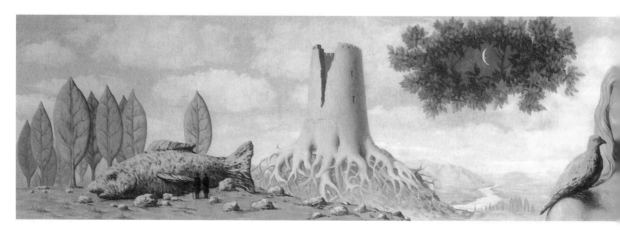

BOTTOM:

The Ignorant Fairy, 1957
In this fresco from the Palais des Beaux-Arts at Charleroi, painting appears to the observer as an "ignorant fairy": it is capable of performing a magic whose sense it does not discern. "Sense is that which is impossible", Magritte repeatedly stated.

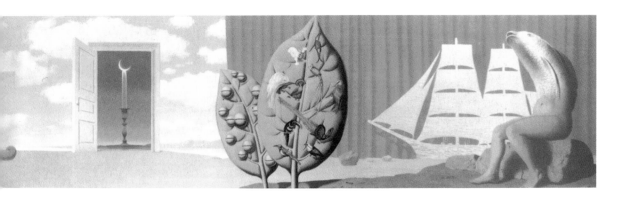

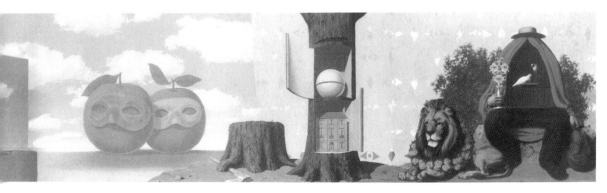

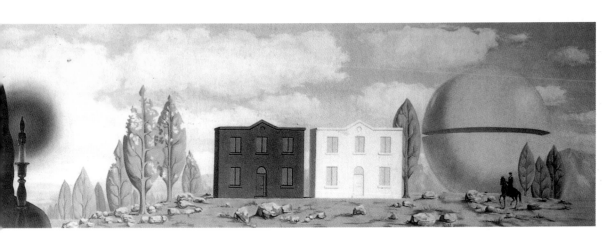

ILLUSTRATION PAGE 34/35:
Interior of the casino of Knokke-le-Zoute
with *The Enchanted Realm* fresco (1953).

33

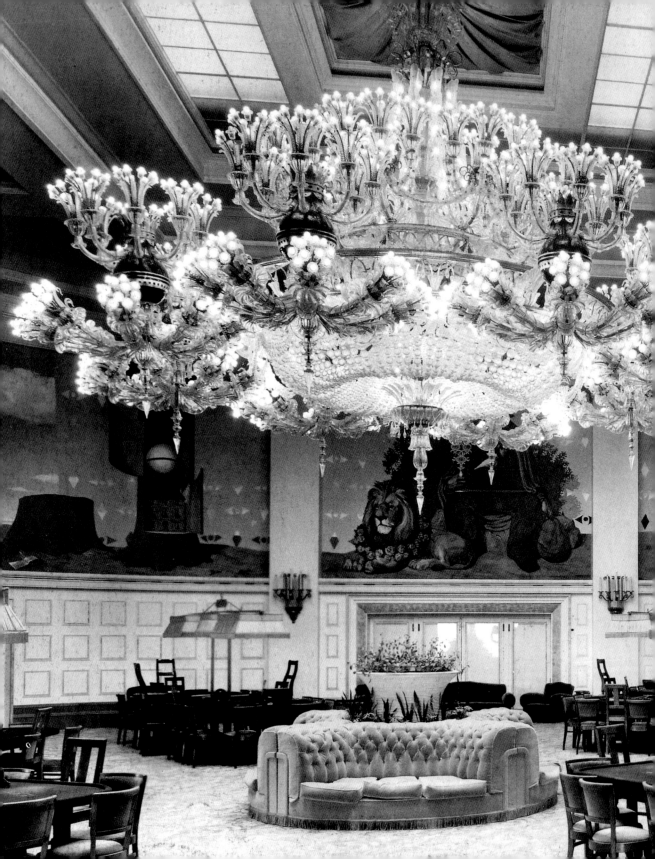

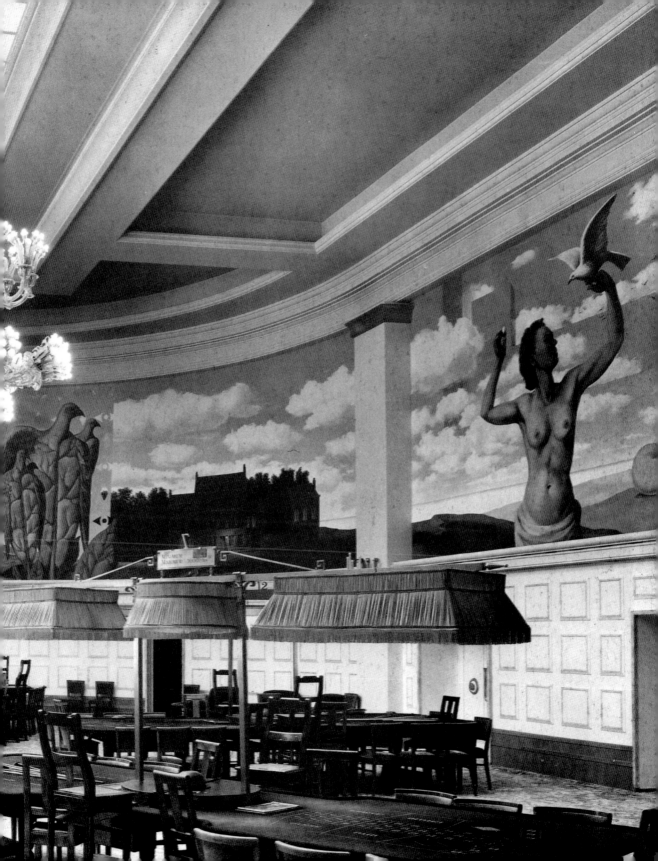

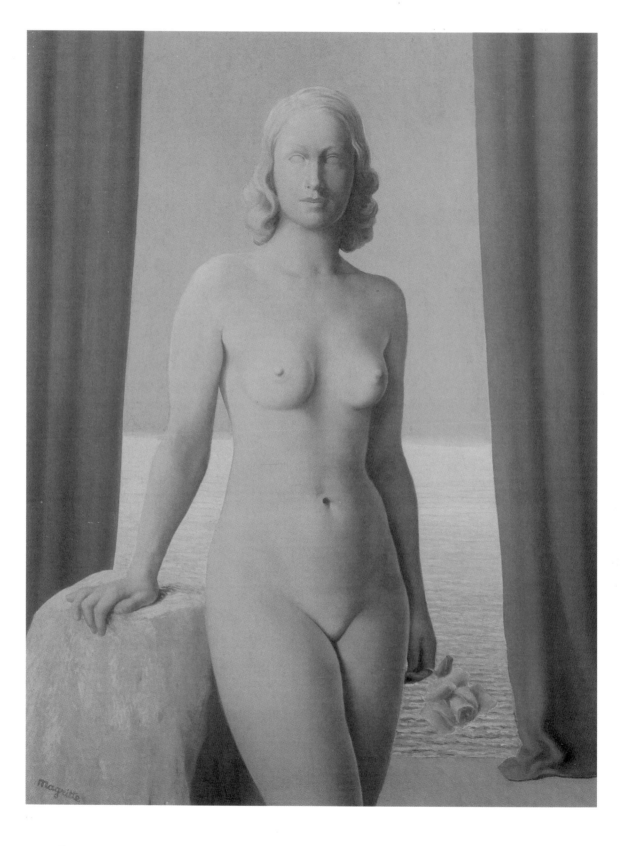

The Enigma of Poetry

Artistic life is not possible in Charleroi. That was the case in 1916, and nothing has changed in this respect down to the present day. Creative figures are confronted with the choice between omnipresent indifference and intellectual stagnation on the one hand, or the difficulties of exile on the other. Magritte chose to move to Brussels, enrolling at the Académie des Beaux-Arts, where he unenthusiastically and irregularly attended courses on literature given by Georges Van Eckhoud and on painting by Constant Montald, the Symbolist. The latter was also the teacher of Paul Delvaux and André Masson, the young Frenchman whose precocious talent had resulted in his being admitted to the courses from the age of thirteen.

Masson had already left by the time Magritte arrived in the Belgian capital, experiencing the indescribable horror of war as an infantry soldier right at the front. Neither Kubrick's *Paths of Glory*, nor Céline's *Journey to the End of Night*, nor even Ernst Jünger's *The Storm of Steel* come near to portraying the military horror of which Masson spoke and which remained a harrowing memory for him his whole life long. The author had numerous discussions with him, in which Masson spoke of Heidegger's considerations regarding Sartre's *Being and Nothingness* ("he's put in too much of the Nothingness"), as well as of the German thinker's view that he had discovered and come to an understanding of painting "too late". In the course of these conversations, Masson inevitably came to speak of the "cleansing of the trenches", that moment in which Frenchman shot at Frenchman, German at German, so that the lines might be "set up again" in order that the command to launch an assault issued the following day could be executed with the minimum of complications.

Magritte, who – unlike Max Ernst and others – always shared the utmost admiration felt by Masson for the author of "Being and Time", had no first-hand experience of the horrors of trench warfare. What he did know, however, was deprivation and constraint, that loathing of the gulf fundamentally separating artistic doctrine from the requirements and mysteries of poetry. He consoled himself about such defects through reading, for example "Fantômas", the figure mentioned earlier, to whom he remained loyal all his life, but especially the works of Robert Louis Stevenson, to whom he paid ardent homage in several versions of "Treasure Island". When leaves are transformed into birds, their stalks into perches, then one ceases to be amazed at anything any more. Such a metamorphosis of flora to take on the form of fauna occurs in *The Companions of Fear* (ill. p. 39) and various other works. Stevenson alternates in a highly artistic manner between realism and romanticism, strict description and the wonderful; Magritte, similarly, abandons and calls into question the

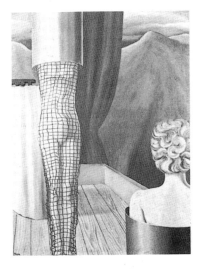

The Accomplices of the Magician or the Age of Marvels, 1926

Flowers of Evil, 1946
"It was the unexpected picture of a statue of flesh and blood, of a woman holding a rose of flesh in her hand. I saw the sea behind her through two red curtains. The title, 'Flowers of Evil', complements the picture like a name that refers to its object without either illustrating or explaining it." René Magritte

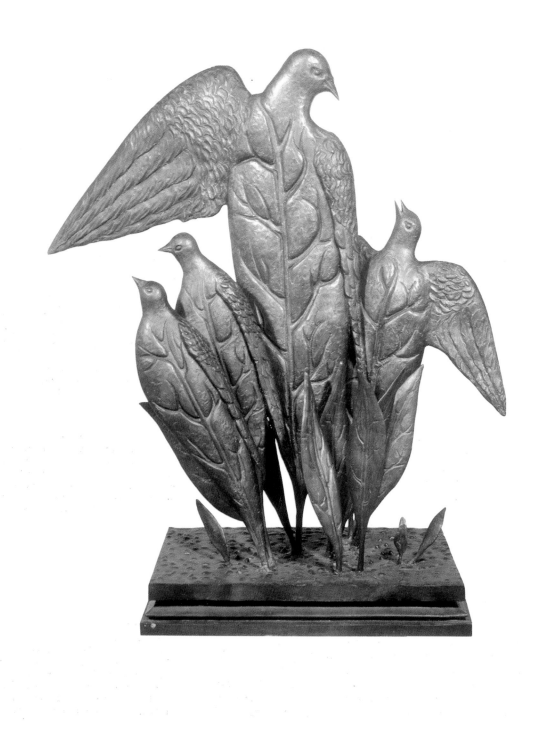

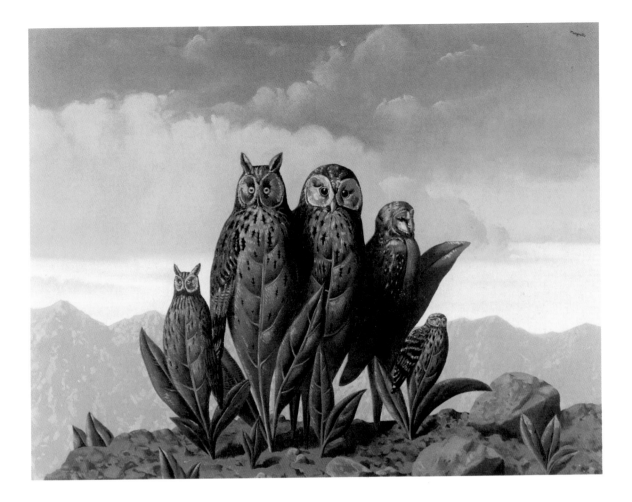

firm basis of common perception through the unexpected manifestation
of the unreal. What he was seeking, stimulated by his reading of Steven-
son but as yet without any firm direction, was concerned less with the re-
lationship of form and colour, or other questions affecting the form of pic-
torial composition than with the concept of visible reality and its inherent
fragility.

It is not only to Stevenson that Magritte makes reference in his pic-
tures. Mention should be made of Hegel as regards *In Praise of Dialec-
tics* (ill. p. 20), Baudelaire in connection with *Flowers of Evil* (ill. p. 36)
and *The Giantess* (ill. p. 40), as well as Verlaine, Heidegger and Lautré-
amont. More than any other writer or philosopher cited here, however, it
was without doubt Edgar Allan Poe who exercised the most powerful
and lasting influence upon Magritte's thinking and on his work as a
whole.

Take, for example, the well-known story "The Purloined Letter". A
minister who enjoys the confidence of the royal couple observes the
Queen trying – successfully – to conceal a letter from her august
spouse. Before the Queen's eyes, the minister steals the letter, substitut-
ing another for it. The Queen has no choice but to remain silent; any
protest at the theft would inevitably bring with it the disclosure of the

The Companions of Fear, 1942
A further variant of Magritte's leaf-birds, here
owls – thus definitely nocturnal animals. The
plant-creatures appear to be growing out of
the rock, like some living – albeit frozen –
monument or memorial, watching over the ex-
panse of a bleak mountainous landscape.

ILLUSTRATION PAGE 38:
The Natural Graces, 1967
The bronze sculpture by Berrocal takes up the
"Treasure Island" theme. Robert Louis Steven-
son understood how to allow that which
arouses wonder to look out from a realistic de-
scription. These magnificent leaf-birds with-
out branches or trees are dedicated to him.

39

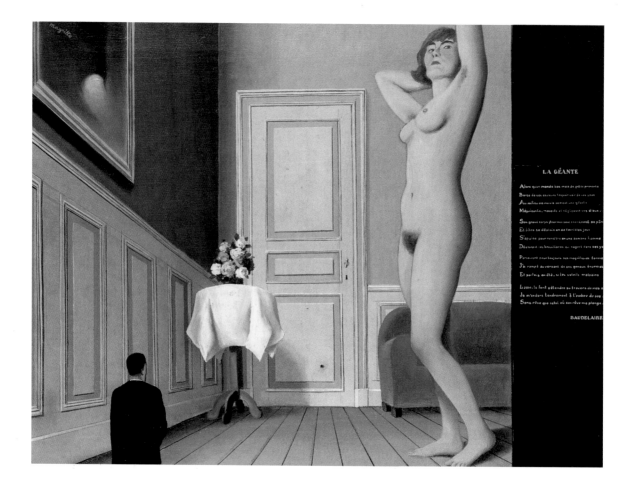

The Giantess, 1929/30
Baudelaire's poem – it also exists in other versions to the one which served Magritte as inspiration – describes the wonderful and sensuous powers of poetry. It is precisely that which the artist is seeking to render here in pictorial form.

very piece of evidence which she is seeking to keep secret. In order to extricate herself from this dependence, the Queen instructs the Prefect of Police to recover the stolen letter, taking care to describe to him the seal of red wax with which it was closed. The poor official sets to work, blindly and without further thought, yet all his investigations come to naught. In contrast, Dupin, whom he has told of his misfortune, strikes it lucky, immediately espying the letter in the minister's cabinet. On a second visit to the cabinet, he sees no more than the reverse of the letter, crumpled and closed with a black seal. He nevertheless manages to recover it by means of a clever tactic: he arranges for a shot to be fired outside in the street, and when the minister opens the window to see what has happened, the cunning Dupin seizes the letter, conjurer-like, substituting another letter for it, in which is written – in Dupin's own handwriting, with which the minister is familiar – some lines by Crébillon the Older: "... such a sinister plan, if unworthy of Atreus, is worthy of Thyestes."

The letter, the written word, which has been stolen here, alters its meaning upon changing owner, since the new owner, the communication falling into his possession, himself becomes one possessed. What in the Queen's hands is a declaration of love proving her infidelity becomes in those of the minister a means of blackmail, albeit one which turns out to

be unusable, since it calls into question the very unity between King and Queen from which he, the minister, draws his entire power. The letter in his hand simultaneously provides evidence of the disorder which it is his job to prevent; he cannot restore order without doing himself harm. Dupin, in stealing back the letter, reveals the conceited, narcissistic superiority of the minister to be no more than illusion: all that is lacking is that the latter, following the example of Thyestes, should devour his own children. Dupin sells the letter to the Prefect of Police, who, for his part has seen nothing and understood less. The Prefect's mistake lay in searching for the real letter, rather than for its sense, which is modified every time the letter changes owners or external appearance. This story by Edgar Allan Poe, in which the actors are divided into observers of action and observers of reflection, reads like an introduction to the art of Magritte. It is not sufficient, upon looking at his pictures, to study what can be seen, to check identities; rather, it is necessary to reflect upon what one sees, to imagine it.

It is only through such a meditative attitude that the observer can gain access to Magritte's subtle game of enigmas. This does not mean, however, that it is possible to grasp this mystery as one would a possession. Reflection merely enables one to sense the mystery; it does not offer any concept, any formula, any key. Patrick Waldberg has rightly remarked that one could speak here of a "key of ashes", one which opens up nothing and fits no lock. The thoughts which become visible in Magritte's pictures lock up their secret as soon as the observer believes that he has completely plumbed the depths of their meaning. The images are poetic through and through.

The Domain of Arnheim (ill. p. 42), a principal work which exists in different versions on canvas and in gouache, emphasizes in another way the unreserved admiration which Magritte evinced for Edgar Allan Poe. The artist borrowed the title from Poe, depicting a mountain with the form of an eagle, while two bird's eggs in the foreground refer to the

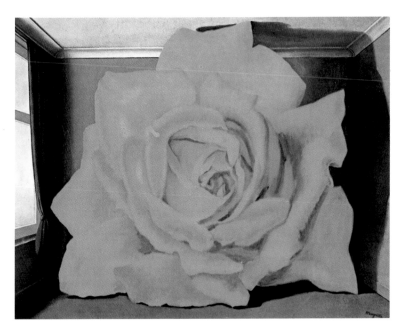

The Tomb of the Wrestlers, 1961
"A rose is a rose is a rose..." Gertrude Stein's famous observation could be taken as commentary on this picture. The overdimensional, blossoming red rose reveals characteristics of a pronouncedly bodily nature; it accordingly possesses an aura that is almost erotic.

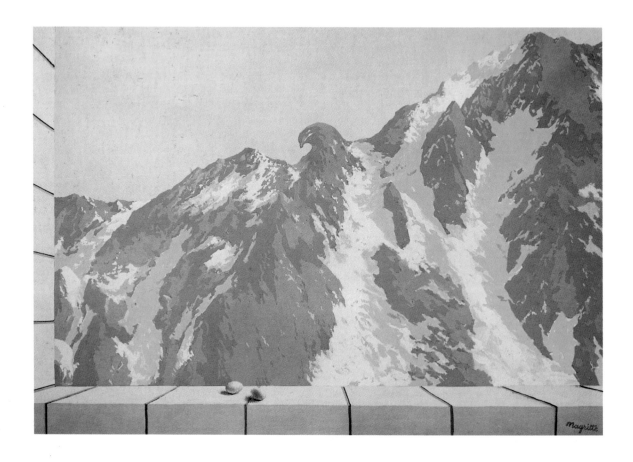

The Domain of Arnheim, 1938
The story of "The Domain of Arnheim", by
Edgar Allan Poe, the American writer, con-
tains some passages with descriptions of land-
scapes and mountain ranges. Poe, renowned
for his stories dealing with "that which is un-
canny, gruesome, supernatural, in oppressive
suspense", writes in this work: "… no such
combination of scenery exists in nature as the
painter of genius may produce."

lightness of poetry, to the affinity of the latter's nature to that of air. In so
doing, he was establishing a lasting monument to his greatest source of
inspiration.

In addition to what he read, the significance of which has often been
underestimated, Magritte was also inspired by contacts and acquaintances
in Brussels, which were calculated to intensify both his hatred of the es-
tablished order and his passion for the poetic. The first of these acquaint-
ances was Pierre Bourgeois, together with whom Magritte had done his
military service. Bourgeois introduced Magritte to the Futurists, whom he
joined for a few years, albeit in a highly unorthodox manner. He was far
more inspired by their eroticism than by their belief in progress and the
grandiose promises that technology held out for the future. It was for this
reason that the poets Edouard Mesens and Marcel Lecomte were able to
so decisively support Magritte in the initial years of his development.
Mesens, the piano teacher of Magritte's brother Paul, already held the art-
ist's work in some esteem at an early stage, and arranged for him to have
a considerable number of stimulating contacts with the Dadaist circle. He
also provided him with financial assistance by purchasing his pictures, be-
coming Magritte's London agent at the beginning of the 1930s, supported
by Penrose. Lecomte likewise felt an allegiance to Dada, for example
with Clément Pensaers, who produced strange little pamphlets with such
titles as "Bar Nicanor" or "Le pan pan au cul du nu nègre". Magritte, dis-
couraged by his first financial setbacks, had just commenced working as

a textile pattern designer in a wallpaper factory – together, incidentally, with Victor Servranckx, the Cubist painter – when he met Lecomte again. Lecomte showed him the picture of a painting by de Chirico, entitled *Song of Love* (ill. p. 43). The painter was later to write: "That was one of the most moving moments in my life; for the first time, my eyes saw thought."

It is astonishing that Max Ernst was gripped by a similar feeling in Munich in 1919, as was Tanguy in 1923, who even jumped out of a moving bus in order to admire a work by the master of enigma. And it was also de Chirico, whom André Masson held to be "one of the greatest painters in the whole world", who would inspire and enthuse the other important representative of Belgian Surrealism, namely Paul Delvaux, born in Huy in 1897 and also a Walloon. In fact, Magritte did not regard Delvaux especially highly, calling him "Monsieur Delvache" (Mr. Del-cow), who "has once again done something or other". There was much to separate these two great painters from each other, for example their reading matter (Delvaux preferred the powers of imagination of Jules Verne, Magritte the poetic austerity of Edgar Allan Poe); the principal difference, however, lay in their respective manners of painting. Delvaux was a "rétinien", a "retina-cretina"; he loved beautiful materials and simple visions, appealed to the emotions and prompted dreams rather than reflection. He was from a well-to-do family, and therefore never had the material worries of Magritte, the rebel; he was a painter of the grey subject-matter, a child more of metaphysics than of the seductive sweetness of the imagination. Magritte did not like Delvaux' populist art, but was nonetheless capable of expressing the admiration due his inspired countryman, who, moreover, had been a great source of inspiration for him, as had once de Chirico. Divergences in mentality and temperament aside, the Surrealists considered that they owed an extraordinary debt to the Italian master of the metaphysical.

1922 was the year in which Magritte married Georgette, the woman of his life; it was also in this year that he made his most far-reaching and most inspiring discovery of the visible, one which without doubt surpassed both the *Blind House* (1853) by Degouve de Nuncques, the source of *The Empire of Lights* (ill. p. 6), and Max Ernst's overwhelming collages, for which Magritte had always felt great admiration. In addition to E. L. T. Mesens and Marcel Lecomte, Camille Goemans was also of great importance for the painter, who settled in Paris in 1927. In October of that same year, the Magrittes went to Perreux-sur-Marne. Nor should André Souris, Van Bruaene and – in particular – Paul Nougé be left out, the latter a man of letters whom Magritte perhaps admired as deeply as he did Stevenson and Poe, not forgetting Mallarmé. The best commentary on the picture *The Blank Page* (ill. p. 47), in which the moon is visible *in front of*, rather than behind, a curtain of leaves, may be found in "Brise marine", while the flower that is "present in every bouquet", formed purely of words found by poetry, surely receives its finest hymn of praise in the thoughts behind such works as *The Ready-Made Bouquet* (ill. p. 46) or *The Tomb of the Wrestlers* (ill. p. 41). For reasons unknown to us, Paul Nougé fell out with Magritte to such an extent that he advised Max Loreau, the philosopher, against ever visiting him, and always replied to every one of Patrick Waldberg's questions: "The dear fellow no longer interests me." Nougé nonetheless was later to write, in "Les Images défendues", one of the most heartfelt homages ever dedicated to Magritte: "A bell, a forest, a woman's torso, a piece of sky. A curtain, a

Giorgio de Chirico:
Song of Love, 1914

Drawing from the "Pour illustrer Magritte" book, Les Lèvres Nues (Bare Lips), April 1970

The Eminence Grise, 1938

43

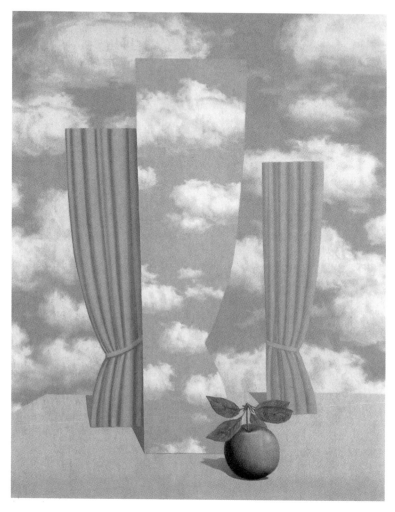

hand, a mountain, in the midst of the silence of proclamation. And a mys-
terious wind is getting up; the experiment is about to begin."

It was also through Paul Nougé that Louis Scutenaire met Magritte.
This encounter occurred in 1926, in "Cirio", a Brussels café, which has
remained unchanged down to the present day. Scutenaire's "Inscrip-
tions", published in Paris in 1945, contains a sentence on Magritte which
precisely sums up the latter's singular genius: "He made use of his prison
in order that he might escape." There exists no apter commentary on
Beautiful World (ill. p.44). The picture demonstrates how the painter em-
ploys what is visible as a curtain, as a means of concealment, making use
of this concealment to prepare a trap for it by compelling it to reveal it-
self. The same obsession may be observed in *Transfer* (ill. p.49), a work
stolen from Chaïm Perelman, the philosopher, shortly before his death, to
appear again later in London. Like Alphonse de Woulhens, this specialist
in rhetoric and argumentation was very well known to Magritte, who also
read Hegel, Heidegger, Foucault, Husserl, Nietzsche and Plato. The art-
ist's reading matter further included "The Songs of Maldoror" by Lautréa-

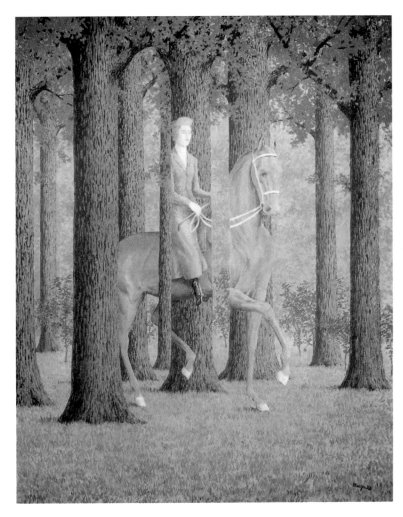

Carte Blanche, 1965
"Visible things can be invisible. If somebody rides a horse through a wood, at first one sees them, and then not, yet one knows that they are there. In *Carte Blanche*, the rider is hiding the trees, and the trees are hiding her. However, our powers of thought grasp both the visible and the invisible – and I make use of painting to render thoughts visible."

René Magritte

tréamont, published in Belgium in 1870 but not until 1885 in Paris (by Huysmans and Léon Bloy), Iwan Gilkin deciding only now to present to the French the poet who had sent Max Waller, Camille Lemonnier, Rodenbach, and all the Symbolists of the "La Jeune Belgique" group into raptures. There can be no doubt that Magritte's illustrations to "The Songs of Maldoror" belong to the finest examples of a genre in which the Surrealists generally shone.

Since 1926 and his picture *The Lost Jockey* (ill. p. 16), Magritte had conceived of himself as a Surrealist; inevitably, therefore, he was tempted by the Parisian adventure. He accordingly went to further the respect accorded the foreign painters, who were bestowing such splendour upon a movement which was in fact so "Parisian" in nature. It was during these years, between 1927 and 1930, that his deep friendship with Max Ernst, Dalí and – especially – Paul Eluard developed. After growing up in the Belgian country, serious, profound, frail socially but stable intellectually, easily hurt but basically unshakeable, Magritte had decided to live in a suburb of Paris. However, his unassuming origins and fear of failure did

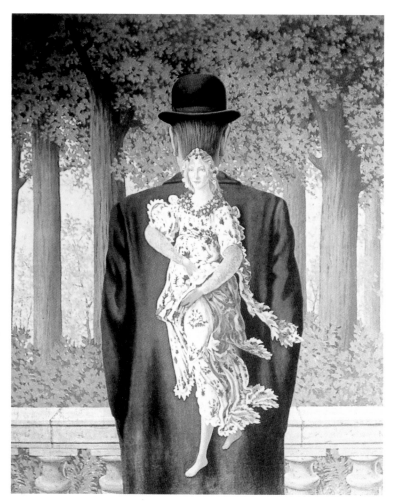

The Ready-Made Bouquet, 1956
For a time, Magritte enjoyed combining motifs from his own repertoire with those from art history: so here, where we see the rear view of his man in a bowler hat together with Botticelli's famous Flora from *The Primavera*. The combination has an effect that is equally unfamiliar and mysterious, a further example of Magritte's poetic and surreal intentions in his art.

not fit in well with the lavish and expensive Parisian lifestyle. He accordingly returned to Brussels with his wife in 1930, where he found new friends, among them Harry Torczyner, a lawyer from Antwerp living today in New York, and Marcel Mariën. However, Magritte was later to break with the latter, after Mariën had had a leaflet in the form of a bank note depicting Magritte distributed at the official opening of *The Enchanted Realm* fresco (ill. pp. 32/33), intending in this way to denounce the petty-bourgeois nature of his friend, who had been granted this late – if important – success.

Magritte twice joined the Communist Party in the years prior to the Second World War, in 1932 and 1936; despite his socialist inclinations, however, realism was not for him, and doctrinaire attitudes put him off again and again. He spent the war years in Brussels, constantly afraid of arbitrary raids and attacks upon his "degenerate" art. This presumably constitutes a further reason why he felt the need after 1945 to change his style of painting, now creating pictures in the style of Renoir, cheerful and ironic works. A series of crude, coarse pictures followed, described

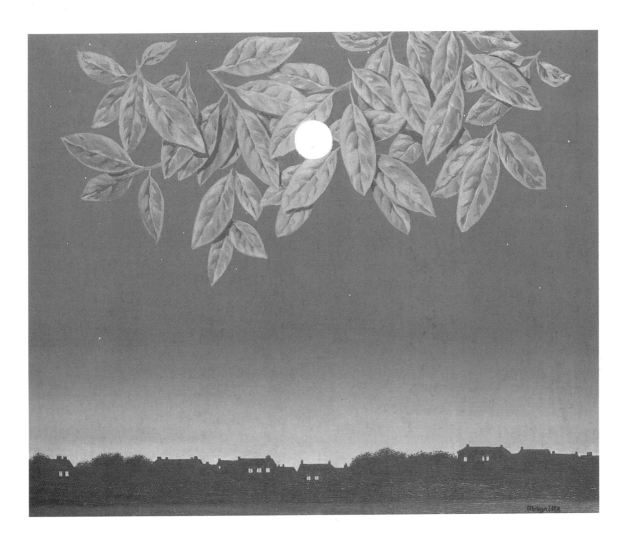

The Blank Page, 1967
Further homage to Mallarmé, who meditated upon the impossibility of handwriting upon a blank page. In this picture, the moon is rising in an impossible constellation – it is located in front of, and not under or behind, the leaves.

by his friends as "vache" (literally, "cowlike", meaning "crude", "un-fashionable"). Jean Dubuffet would certainly have approved of this style: one can hardly deny the affinity that his *Bird-eaters* share with the savage wildness of such a work as *Pleasure* (ill. p. 75). Yet neither the sensual gracefulness of a Renoir nor the coarseness of a Jean Dubuffet would ulti-mately provide Magritte with a path that he could take. For this reason, he soon returned to his old style, which had experienced enrichment through refined shades of blue and a painting technique that was more flowing, more sensuous. Success gradually arrived, thanks to Iolas, his agent, and to America. Despite all the disagreements which they had gone through earlier, Breton opened his American exhibition in 1964 with words which have stuck in Patrick Waldberg's memory: "Every-thing that Magritte has done represents the culmination of that which Apollinaire once described as 'true common sense' – that is, that of the great poets."

Magritte disproved the legend of the exceptional longevity granted painters, dying of cancer at the age of 69.

Illustrations for "Les nécessités de la vie"
(The Necessities of Life) by Paul Eluard, 1945

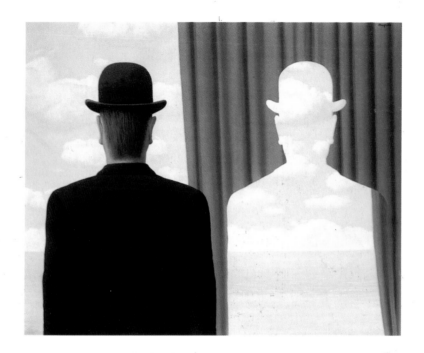

TOP:

Transfer, 1966

The left-hand silhouette appears to have been cut out of the folds of the curtain, as sand and sea are rendered visible. This is incorrect, however; the cut-out is not identical. It is all merely painting, demonstrating to us that what we see, from which painting selects a part, consists of a close network of coverings-up that are endless in number.

BOTTOM:

<u>Duane Michals</u>:
Double portrait of the artist, 1965

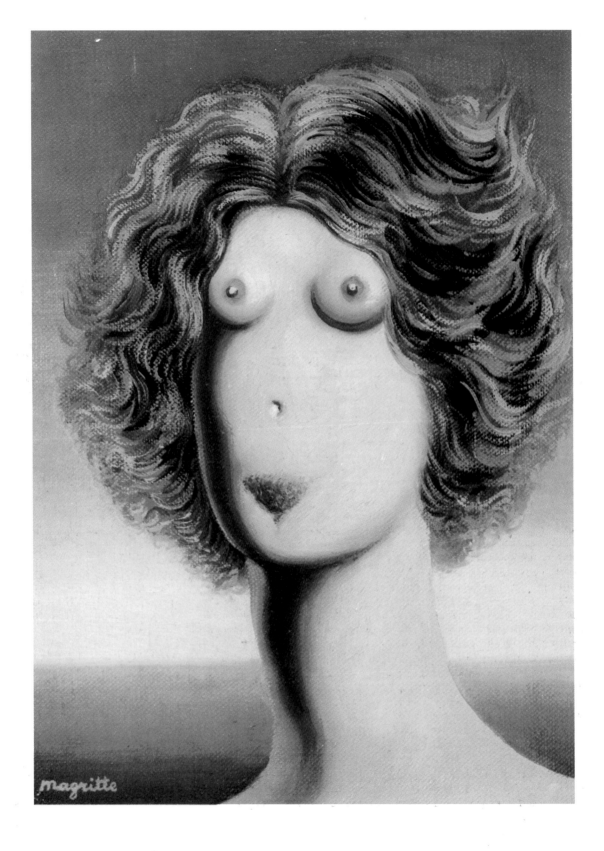

The Body in Painting

The picture *The Rape* (ill. p. 50) demonstrates all too obviously that painting is also capable of taking hold of the anatomy of the human body, capturing it in pictures and transforming it. The eyes become breasts, the nose – the middle of the face – is now the navel, the mouth the genitals. Nevertheless, the violence done to the face of the woman is not arbitrary in nature. The anatomy of the picture, to take up an expression from Paul Klee and Hans Bellmer, makes the observer aware of his voyeuristic status; he circles the "eyes", the "nose", the "mouth", and appreciates the sex-appeal of this navel display. If a rape indeed takes place here, then it is that of painting itself, which, not content with reproducing the world of visible appearances on the canvas, seeks to transform it, to force it open. Painting wishes to do as it wants with that which is visible by means of a poetic, magical order, an order permitting the observer's gaze to penetrate to the innermost centre, to the body, to the senses. The principal concern here is not so much to copy reality, to glorify the manifestations of objects in the world, but rather to create a picture of the body such as will reveal its deeper, hidden nature, a nature customarily hidden from the observer's gaze yet nonetheless existing inside the head.

The work *The White Race* (ill. p. 65) presents a surprising vision of the human body and establishes a new hierarchy of values. There is only one eye, one ear; eyes and ears are unique, like the mouth, the organ of speech. The solitary, cyclops-like eye, its dominant central position at the very top evoking a sense of transcendence, is located above the ear, which in turn is borne by the mouth. The eye (organ of pictures), the ear (organ of sounds) and the mouth (organ of the word, of the *logos*) are supported by two noses, which may be regarded as legs. They effectively constitute all of the remaining body, the entire diversity of the other senses, which are used as a block, as a pedestal. *The Rape* and *The White Race* convey the impression of general discord among the sensory organs, the impression of a quite fundamental "disorder". This is the case not only with respect to each individual sensory organ (the mouth eats, drinks, speaks, sucks, kisses; the eye sees, reads, scrutinizes, reflects, can express desire or contempt, rage or tenderness) but also regarding the relation between the different senses (the eye can become the breast, just as the mouth can become the genitals, or the nose the navel, and so forth). Such mobility among the organs of the body – their ability to change function and sense – basically implies a conception of the human body which has nothing in common with the laws of anatomy and legal identity. Magritte is presenting the body as a shattered multiplicity, fragmentary and fragmented, like a puzzle made up of pieces which do not fit together, as a field of possible variations, as the place

Natural Knowledge, undated

The Rape, 1934
"Love is approached via the face, and is fulfilled in the body. Hence the wonderful love which one has of the entire woman, face and body in one whole. In contrast, however, this superimposing upon the face of the trunk (the breasts look at you, the nose has atrophied into the navel, the pubis/mouth seems distorted into a tormented grimace), far from being the spiritualization of the corporeal, signifies rather the degradation to an object of sexual desire: blinded, deaf and dumb."

René Passeron

51

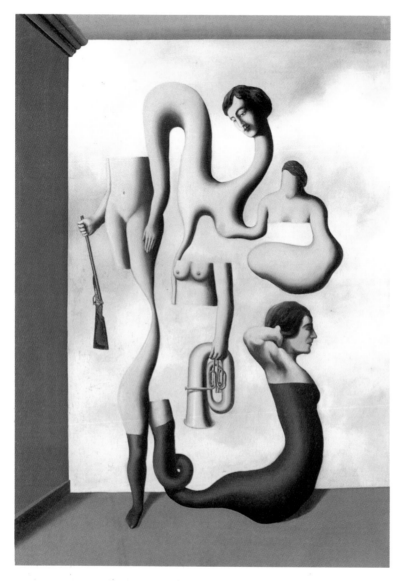

The Acrobat's Exercises, 1928
An important characteristic of the acrobat is his ability to free himself from the normal conditions offered by the body. Magritte describes this as the "spirit which – analogous to the body – walks, goes away, or remains".

where forces that are most disparate in nature, sensations that are hete-rogeneous and changing, encounter – and sometimes ignore – each other. He is aiming not so much at the intimate harmony or the unity of the body as rather at the possibility that art presents of questioning the cohesion of the body.

Following the example of Fantômas, who is constantly changing his identity, the painter now gives the body the ability to escape from its so-ciocultural identity. He allows it to contradict the picture which our civi-lization would make of it. Western thinkers have been convinced since Sophocles and Plato that sight constitutes a power which – godlike – dominates the other senses, rules over the body, keeping all other sensory perceptions in check. This pre-eminence of *Theoria*, of sight, has re-mained completely unchallenged in the history of philosophy, with very

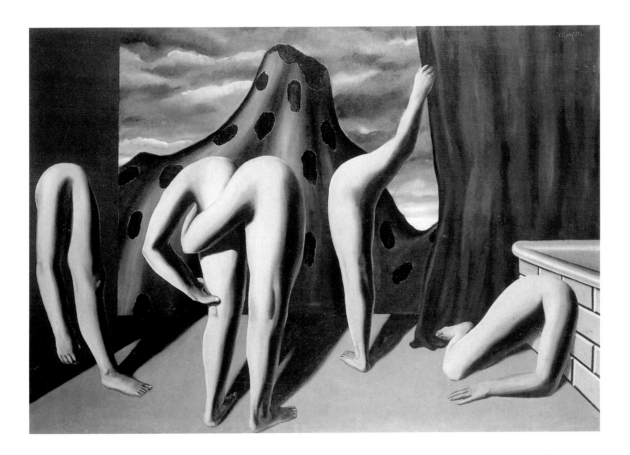

few exceptions. It is unquestioned by those authors whom Magritte read with enthusiasm, appearing in Aristotle's "Metaphysics", in Descartes' "Idées claires et distinctes", in Kant – inasmuch as he conceives of sensibility as derived from intuition – and also, finally, in phenomenology, from Husserl to Heidegger. In short, the emphasis upon the visual element has increased considerably in the meantime: we live in a world of pictures, a world of spectacle. The audiovisual arts ought to maintain the balance between the audible and the visible to a greater extent than the others, or establish a harmonious connection between these two areas; even they, however, attach an importance to the visual element that is frankly foolish. *The White Race* is accordingly characterized quite unambiguously by the selective hierarchy of shades, as also suggested by Magritte himself – in contrast to the native civilization, where sounds predominate. Through this picture, and the sculpture created in the studios of Bonvincini and Berrocal in Italy, Magritte is drawing attention to the imbalance between the senses, indicating the possibility of establishing a form of modifiable, revocable relationship between them.

The White Race thus represents nothing other than a hierarchy of the senses; yet an uncountable number of other possibilities of organization also exist in addition to this one. It is not via one single, self-contained realm that sensory perception takes place, but rather via the entire, open diversity of what can be seen and heard, of what can be felt, tasted, smelt, and so forth. Accordingly, a work of art, inasmuch as it addresses sensory

Intermission, 1927/28
The show has been interrupted. All those bodily fragments left in the background, everything living in the wings of visibility, suddenly appears in the foreground.

ILLUSTRATION PAGE 54:
Dangerous Liaisons, 1926
On the basis of the mirror image, perceived certainties are once again called into question. The relationship between the mirror and that which it reflects, a relationship commonly regarded as indissoluble, appears broken. A naked young woman may be seen in altered perspective *in* the mirror *behind* which she is standing, yet the observer, who is located *in front of* the mirror, would expect to see himself reflected in it.

ILLUSTRATION PAGE 55:
Eternal Evidence, 1930
Each picture records only a fragmentary view of the body, each view selected from an endless number of possible visual approaches. Here we see five sections, which do not completely fit together, demonstrating the problems inherent in the act of painting.

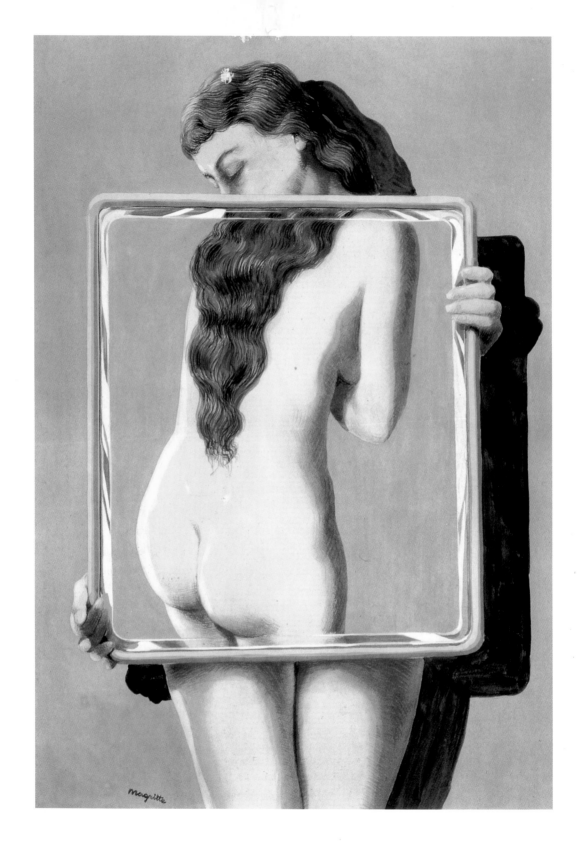

perception, is by no means so isolated and self-contained as people are traditionally prone to maintain. Berrocal understood this precisely, following Picasso, presenting the public with series of sculptures such as enable the owner himself to make literally endless variations upon them. The owners, however, continue to prefer the old custom, whereby they persist in maintaining their respectful distance to the artist's work, regarding it as the finished product, as the result. Yet life and our bodies undergo change; the senses enter into different associations, and the preferential treatment accorded one of them can condemn the others to a kind of shadowy existence, a hidden presence.

Magritte's primary concern is always to reveal what is concealed by what we can see. In *The Lovers* (ill. p. 64), he points to the blind nature of love by doubling what is obvious and placing a veil over the faces of the lovers, who are thus left to their sweet blindness. Yet the task here is to utilize this game of concealment through that which is visible, to compel the veil to reveal what lies behind the view which is generally presented. Georgette's piano encompassed by an engagement ring indicates the double power which *A Happy Touch* (ill. p. 63) has in music and in love, without there being any visible sign in the work of this touch – which is simultaneously a metaphor for silence: one can hear the sound of rushing water in a basin, for example, or a car driving past, children playing or a symphony by Mozart, but never absolutely pure sounds. The sole sound that is absolutely pure is that of silence. An apple fills the entire pictorial space: *The Listening-Room* (ill. p. 63). The observer's gaze is satiated, leaving only the appeal to another wonderful ability, that of hearing. That which is visible covers up and veils, but it can be overcome with its own weapons: by painting it, the invisible can be exposed, can be compelled to reveal the entire secret that is lying concealed within it, that which it ultimately – in a deeper sense – *is*.

The mystery of what is visible is to be found in the body, in the powers of the body, a discovery conveyed by *The Acrobat's Exercises* (ill. p. 52). The suppleness of the acrobat, holding a death-dealing rifle in his right hand, a musical instrument in his left; the head, depicted three times; the sexual organs, totally excluded under these impossible athletic contortions – Magritte makes use of all of these elements to render apparent in a single picture those abilities and aspects of the body that are hidden from the eye. The painting is able to portray the visible aspect in such a refracted manner that the body nonetheless emerges in its true nature, entire, monstrous, and fragmented, despite the completely distorted dimensions. The actual body is not present in the depiction, similar to the manner in which every picture can show merely one section. Likewise, what is visible here may be compared to a piece of clothing that veils, shrouds, protects, but also arouses the desire to "dis-cover" that which is concealed; more, this piece of clothing mutilates the body, in that it detaches it from the part of the body that is visible. The body, whether clothed or painted, is cut up, divided into veiled and unveiled fragments, clothed and naked flesh, in openly displayed nakedness – for example, that of facial skin – and concealed nakedness. Not until it is seen against the backdrop of the theatre of the visible is this interplay itself rendered visible. The mystery of the body, of its variety of powers, is also the mystery of painting, the art of the disloyal, yet not deceitful, mirror: despite the great risk, this art can indeed achieve that which also appears the first task of the visible, namely to conceal, to turn away, to suppress everything lying outside of its own sphere.

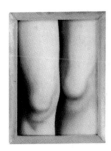

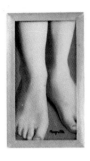

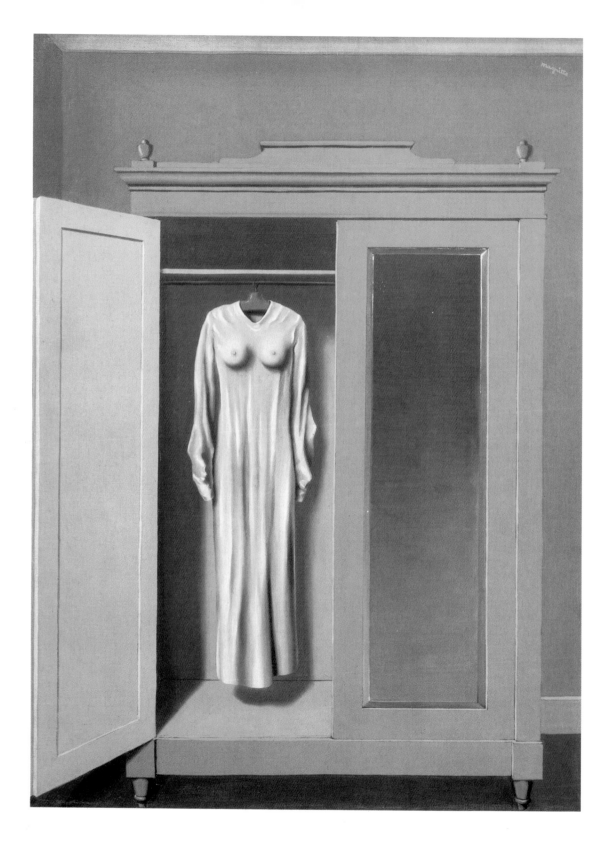

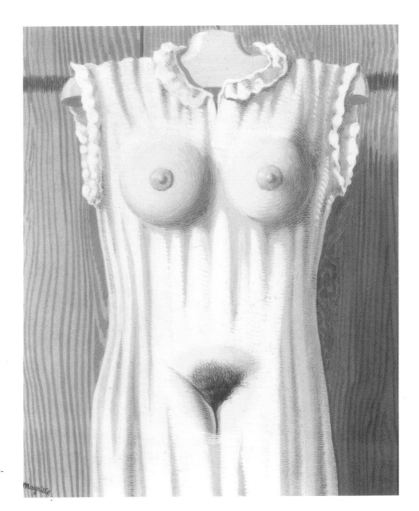

Philosophy in the Bedroom, 1966
Humour recedes before the intensity of the
erotic element. The nightdress reveals quite
undisguisedly that which it is usually its func-
tion to conceal. This portrayal of the look of
desire is a homage to de Sade.

Homage to Mack Sennett, 1937
Mack Sennett, the American director and pro-
ducer, made over 500 films up to the 1930s,
the most successful of which were slapstick
comedies; Magritte, the passionate cinema-
goer, was ever enthusiastic about them.

Painting is thus no passive mirror of reality; rather than doubling the
visible manifestation of the object, it changes and transforms it. Accord-
ingly, painting does not reproduce the body of a woman; instead, it does
quite the opposite, creating a new manifestation, a picture that is partial,
congealed, framed, dead. As far as Magritte's work is concerned, the new
painted manifestation of the object would seem to be quite conscious of
the contribution made by art. Magritte's painting modifies appearances,
rendering them fictitious; at the same time, however, the painter is reflect-
ing upon the sense of such a modification. The nature of his painting
must thus be contemplative. The picture *Dangerous Liaisons* (ill. p.54),
which has been strikingly interpreted by Max Loreau, depicts a naked
woman. The mirror which she is holding in her hands is turned towards
the observer. It covers her body from shoulders to thighs; simultaneously,
however, it reflects precisely that part of her body which it is covering,
seen reduced and from a different perspective. Magritte has thus painted
two different views of the female body, one its direct appearance, the
other the imaginary one of the reflection. He confronts the observer with
two incompatible aspects, compelling him to reflect upon the discrep-
ancy, upon this enigma which is characteristic of this painter's entire

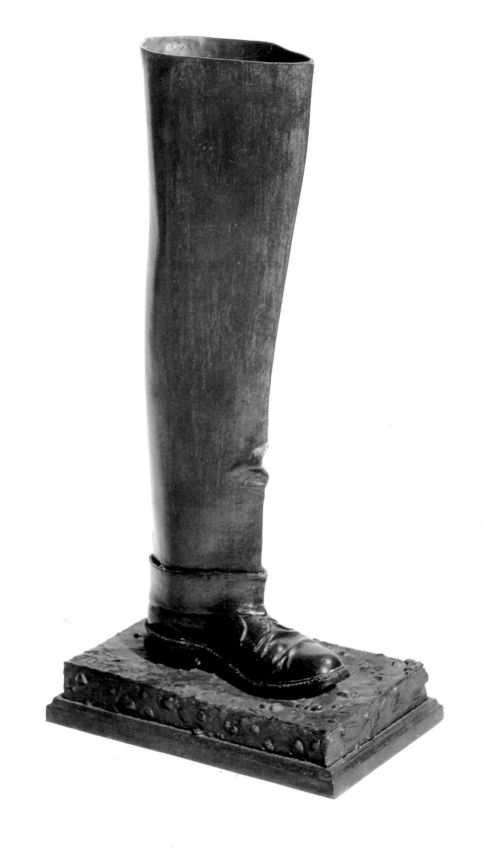

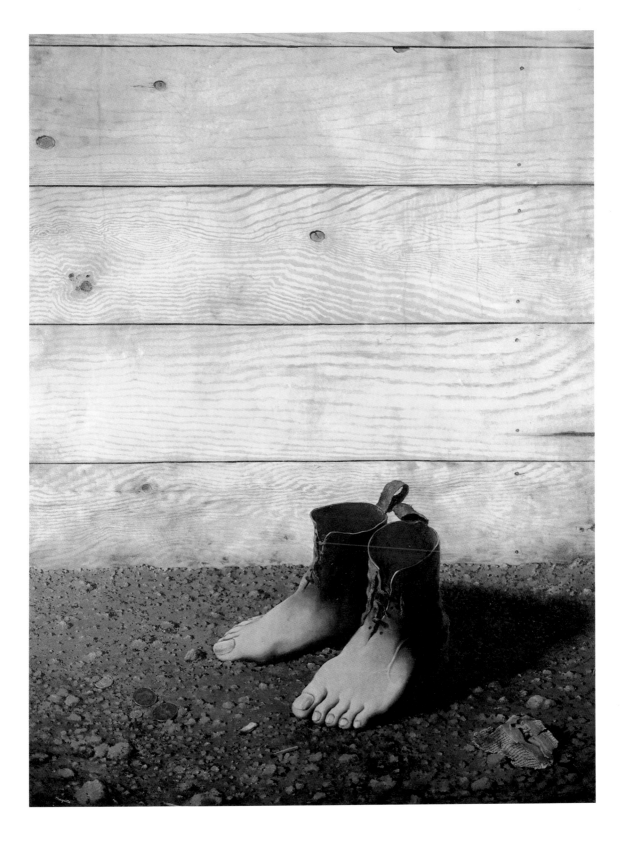

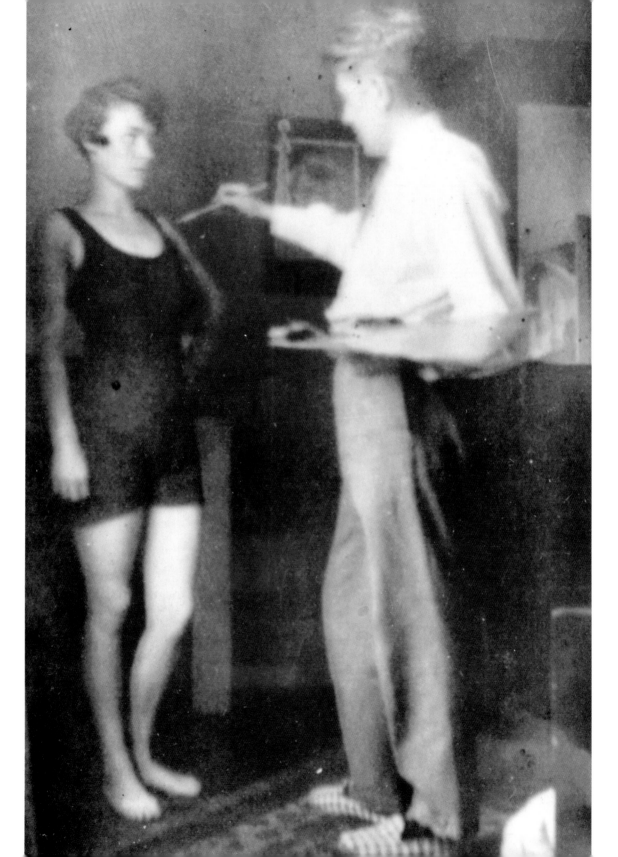

The Well of Truth, 1967

A simple trouser leg with a shoe – the rest of
the body is absent, outside that which can be
seen, outside the work. The never-ending
search can begin, comparable with the search
for truth.

The Red Model, 1937

"The problem of the shoes demonstrates how
easily the most frightful things can be made to
appear completely harmless through the
power of thoughtlessness. Thanks to the
'modèle rouge' (Red Model), one senses that
the union of the human foot and a shoe is in
fact based upon a monstrous custom."

René Magritte

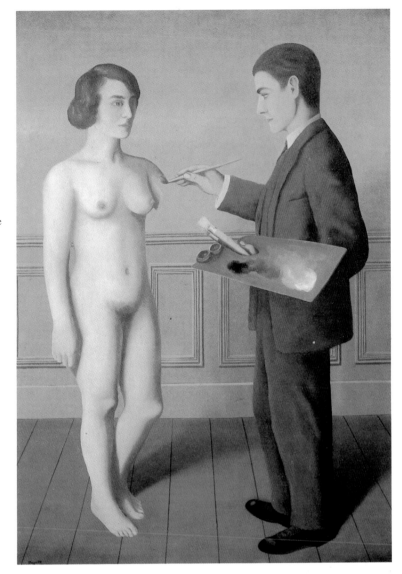

Attempting the Impossible, 1928

A variation upon the legend of the sculptor
Pygmalion, who himself created his dream
woman. Pygmalion required divine assistance
to bring his sculpture to life; here, the artist
succeeds simply through his powers of ima-
gination and his belief in the impossible.

Georgette and René Magritte in Perreux-sur-
Marne, 1928

work. We see the female body, not as a cohesive whole but fragmented
and fractured. Through the painting experience, the body loses its inte-
grity, relinquishing its inner cohesion and taking on a fragmentary appear-
ance. In this particular case, Magritte is further demonstrating that liaisons
are always dangerous in painting, since the perspective of the artist, the
covetous gaze with which he looks at the body of his model, also plays
a role for the work. The woman's body thus develops into the area of
conflict between two incompatible manifestations. Where does this con-
flict come from? This is precisely the point, that it can only stem from
the viewpoint and the work of the artist, who has introduced the pulsa-
tions of his own body into the work in such a way that it would seem
possible to feel them with one's hands. Magritte's art is never passive. On
the contrary, it acts, and always with the intention of creating disquiet, of

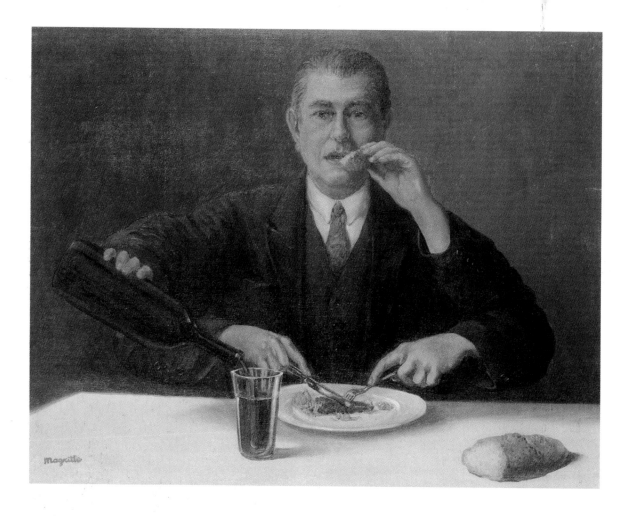

The Magician, 1952
Magritte wrote to a friend in 1953 that *The Magician* was a self-portrait, adding: "Anyone crazy about movement or its opposite will not enjoy this picture." The work, one of Magritte's few self-portraits, shows him in a kind of simultaneous role play in which, thanks to his four arms and hands, he is able to carry out various actions at one and the same time.

being subversive. There is room between the two views of the female body – their proportions and the positioning of the hands such that they cannot be reconciled with each other (it is impossible for the right hand, holding the frame, to be the same as the one which the woman is holding to her breast) – for the tilted edge of the glass pane and the frame of the mirror. The displacement between the two views of the body would thus seem to have been caused by a further displacement, namely that of painting itself. Magritte is demonstrating that painting fills a space between visible reality and imaginary picture. How should this space come about, if not from the body of the painter?

Magritte's magic consists in his having ready a stunningly simple and absolutely overwhelming answer to a very classic problem within painting, one occurring in the works of Alberti, Leonardo, Velázquez, Picasso, and many others, namely the question of the faithfulness of the mirror image, or, put another way, the question of the image of the image. Magritte's solution is that what is visible cannot be separated from the body, from sensory perception, whereby sensory perception is regarded here as an active, even voyeuristic desire, rather than one that is passive, merely observing – a desire concentrating more upon detail than upon the whole. The mystery at the source of all contemplation and all painting is the mys-

TOP RIGHT:

A Happy Touch, 1953
Georgette Magritte's favourite instrument, the piano, is encompassed by a ring in the shape of a bass clef.

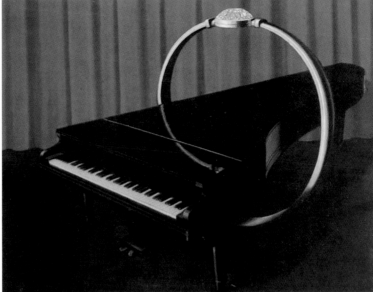

TOP LEFT:

A Happy Touch, 1952
"I was looking at the problem of the grand piano, and the solution showed me that the mysterious object, the one predestined to form an association with the grand piano, was an engagement ring." René Magritte

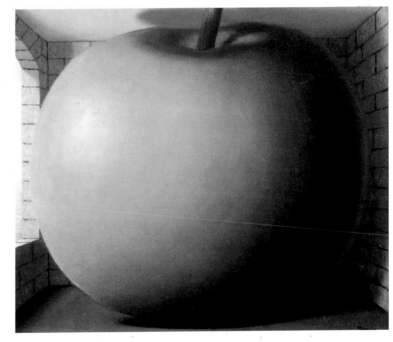

BOTTOM:

The Listening-Room, 1958
"... My pictures, while depicting objects which are so familiar, nonetheless raise questions again and again. Look at the one with an apple, for example: you no longer understand what is so mysterious about it, nor what it is illustrating..." René Magritte

tery of the body itself, that of perception, which is not only torn between the different senses but also captures a multitude of impressions via each individual sense. A similarly confusing effect is produced by the fundamental difference between the picture and the object it portrays. The body in painting may be seen in the picture *The Red Model* (ill. p. 59) at the point where the naked toes protrude from the leather of the footwear, indicating a completely different world. They do not resemble the shoes

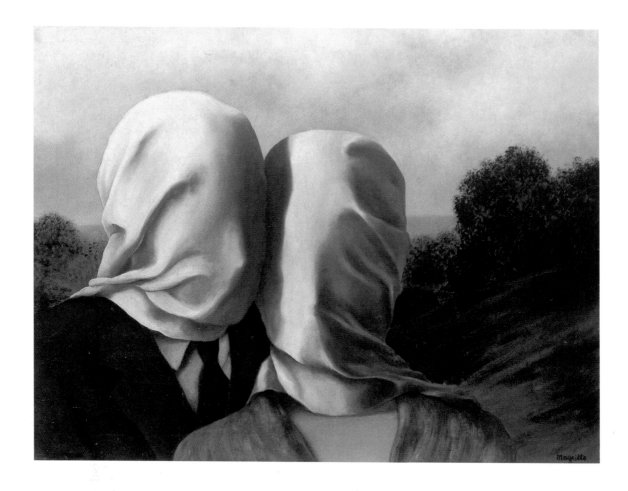

The Lovers, 1928
Magritte was to paint the classic motif of *The Lovers* in 1928 in several versions. He transformed the cliché each time in such a way as to fulfil the demands of Surrealist art, namely to confuse through the apparently familiar – or, better still, to use the apparently familiar to disturb.

of a farmer, a mountaineer, a salesman, a dancer; what all shoes basically have in common, however – whatever the current fashion might be – is the fact that they cover the feet and come into contact with the ground or the floor on which the body is standing upright or adopting some other position. Thanks to its ability to walk upright, does the body not constantly demand that what is visible be given preference at the expense of the other senses, that it be taken up for the art of painting, that its links with the neglected, missing diversity of the other senses be re-established?

The characteristic feature of the erotic in Magritte's art is the fact that the artist, while getting as far as the body, nonetheless remains a prisoner of distance, a prisoner of the space in which the light is playing, light necessary if the eye is to see at all. Eroticism harbours, for painting, the possibility of duplicating the abilities of the body, as may be seen in *The Magician* (ill. p. 62), or of selecting as one thinks fit, as in *Eternal Evidence* (ill. p. 55). Such eroticism can be amusing, as in *Homage to Mack Sennett* (ill. p. 56), the director of Charlie Chaplin and Buster Keaton: the breasts are apparent through the nightdress hanging in the wardrobe – yet the nightdress's very function is to cover them up. Eroticism is equally capable of manifesting itself in an extremely crude fashion, for example placing the emphasis in an all too obvious manner

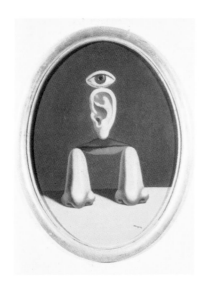

The White Race, 1937

The White Race, 1967
A fragile structure consisting of the facial senses. Does the order reflect a hierarchy of the senses? Or does it emphasize the separation of the senses from the bodily element?

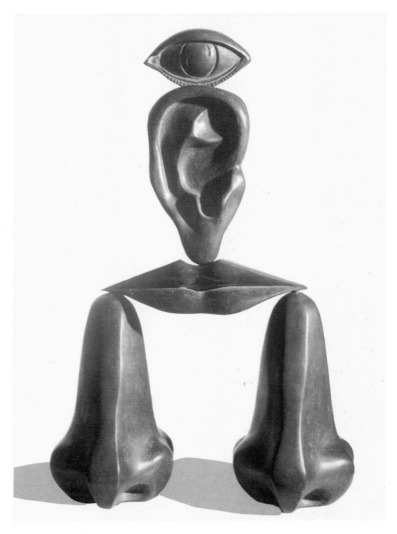

upon pubic hair and full, well-rounded breasts. The title of the picture *Philosophy in the Bedroom* (ill. p. 57) is a reference to Marquis de Sade, who paid a very high price for his free imagination and the fantasms of his erotic art.

The painting *Attempting the Impossible* (ill. p. 61), together with the corresponding photograph (ill. p. 60), may be regarded as the most beautiful homage paid by Magritte to his wife, who was also his model. The painter's desire to immortalize the object of his desire, to capture it on canvas, to create it for himself once again, is tangible – yet, in so doing, he is attempting the impossible, and his intention is doomed to failure. It is this sobering knowledge of the broken spell, this deep, protective melancholy, which runs through Magritte's entire work whenever body and desire are involved.

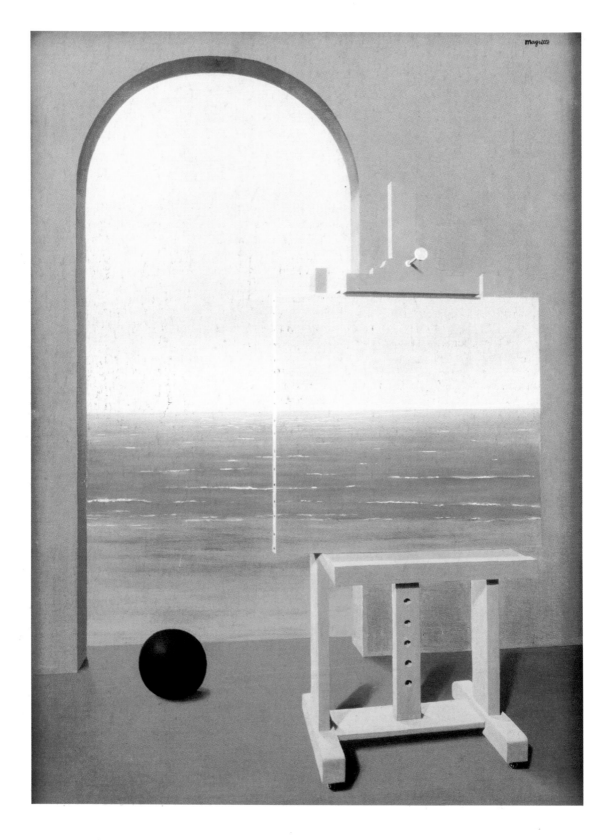

Images and Words

To sum up what we have ascertained so far, the painted image is no common reproduction, since it also depicts the person of the painter, his body, acquired through his way of viewing and technique of painting things, his eye and his hand. The painting does not deliver a means of identification, like a passport photograph; its intention is to draw attention, not to the external reality as such but rather to the unfathomable mystery behind this reality. In Magritte's output, the painted image is always the image of a thought and, as such, the painter demands that it reflect its inherent condition as an image. It is never a simple reproduction of appearances, in the sense of a visual illusion, intended to represent reality.

A painted pipe, as in the work *The Treachery of Images* (ill. p. 9), cannot be smoked. Accordingly, the painted pipe is *no* pipe, in the same way as other pictures by Magritte contain *no* apple, *no* woman, *no* wood and *no* hammer. The work reveals the inner distance to that which is visible, that space in which the art of painting can develop. One feels something like the impotence, the limitations, of painting, since its basic structure and fundamental nature mean that it is separated from reality, from its model. At the same time, however, this separation is the characteristic of a power that is surreal, magical, quite other in nature, namely the ability to betray reality, to allow a rock to hover in mid-air, or to depict an apple that fills the entire space of a room (*The Listening-Room*, ill. p. 63). It is the power to render visible the distance separating the picture from its model. Painting works in conjunction with the visible, functioning within the visible, never outside of it.

Words also belong to the realm of what is visible, however, an aspect which in no way escaped Magritte's poetic astuteness. Only an abstract relationship exists between the "idea" of a horse and the creature known to everyone, for example. Expressed more precisely, this idea has of itself nothing of a horselike quality. Like images, words also play with the difference between their linguistic nature and the things to which it is intended that they should refer. The written words "the Seine", for example, take us in our thoughts to Paris; this is no real process, however, but merely an abstract one. We can thus speak in this case of a certain impotence of words compared with objects. At the same time, however, we discover in them an enormous power, a striking ability to be deceitful. Words are capable of such mendacious claims as "I am on the moon". Magritte's attention was lastingly occupied with and fascinated by this poetic capacity of language. On the canvas, painted words – not as descriptions but as parts of the picture – can release their powers of differentiation, as may be seen in *Dangerous Liaisons* (ill. p. 54), not only in the mirror but also in the body and its fragmentation through the por-

The Human Condition, 1935

Magritte in his studio-salon, 1965

The Human Condition, 1935
Reality and reproduction mingle in Magritte's picture. The work on the easel continues the view of sea and beach almost seamlessly.

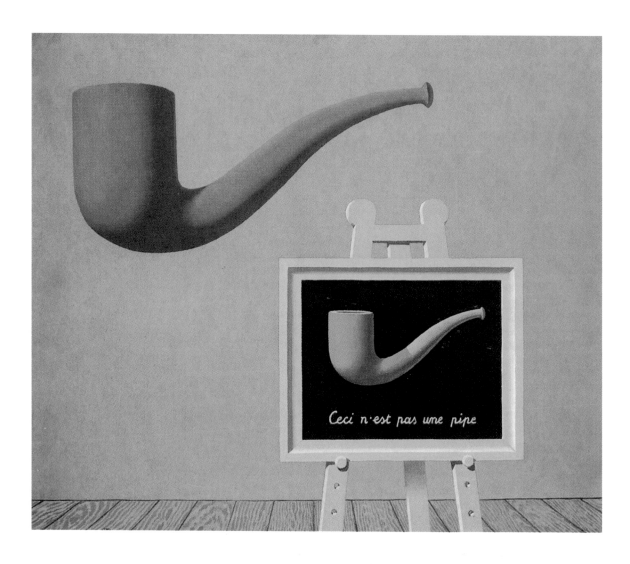

The Two Mysteries, 1966
The representation of a pipe is no pipe – an apparently succinct and banal conclusion which nevertheless conceals all the more the mundane mystery to which Magritte refers again and again: neither the word nor the picture of the object can assure us that the object really exists.

trayal within the picture. We can compare here *The Two Mysteries* (ill. p. 68), or *The Interpretation of Dreams* (ill. p. 71). An indefinable, mysterious space exists between the words and the objects – as between the images and their objects. When Magritte paints words or whole sentences, he is combining the differentiating power of that which can be read with the differentiating power of that which can be seen. In showing the respective freedom available to each of these two, in playing with the freedom offered by the two freedoms, so to speak, Magritte – like Borgès – is undermining the common foundation through which they can mutually identify and communicate with each other. He is allowing a difference to develop *between* the differences, a separation between words and pictures, instead of leading us to believe that the surreal nature of the pictures and the words is identical with their real nature. Identities become unstable under the subversive touch of Magritte's genius; they are rendered fragile, begin to dissolve.

The course of development followed by his work proves that Magritte remained true to his principle, precisely depicting this distance be-

tween that which can be seen and that which can be read. It was never his intention to conceal the difference. Such a kind of common sense can plunge pure realists and humourless souls into confusion; however, it captivates those prepared to be drawn into poetry and intellectual involvement. *The Explanation* (ill. p. 72) is simple. What Magritte is producing with the aid of a carrot and a bottle takes place merely within a surreal picture; it seeks to conjure up not the identity of two realities but the very impossibility of their synthesis. The same is true of another work: Magritte could have portrayed *The Art of Conversation* (ill. p. 76) in his picture by means of an ugly balloon containing the characters' conversation, as in a comic magazine. Yet he has done without this, and so we are left in the dark as to what they are saying. The shape resulting from the appearance of the blocks of stone, however, piled up on top of and within each other, is such as to allow letters to emerge from the confused and unreadable jumble, forming the word "Rêve" (dream). In other words, Magritte is not concerned with constructing through images and words an apparatus intended to capture reality and put a vice-like hold upon it through the alliance of two complementary systems. Rather, he makes use of the inner distance to the words and the outer distance to the images to cause a mystery to appear, a wide-awake, perceptive dream, that untouched, mysterious difference, original thought.

In so doing, Magritte is negating the traditional manner of depiction, and the observer finds himself wondering how anyone could ever have considered the picture of a pipe to be the pipe itself. Those people who hold that there is a correspondence between words or images and the objects themselves are doubtless those same people who believe nowadays in the veracity of the information provided by television and uncritically allow themselves to be impressed by a totalitarian propaganda disseminated under the cloak of freedom of information. When the Italian state sought to use the picture *The Flavour of Tears* (ill. p. 73) for its perfidious anti-smoking campaign, Georgette Magritte refused, pointing out that her husband "had not painted the picture with the intention of hindering people from smoking". The seductive effect of his works, in which

Drawing from the "Pour illustrer Magritte" book, Les Lèvres Nues, April 1970

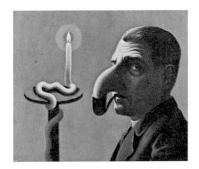

The Philosophical Lamp, 1936
This combination of snake-like candle of cognition and Magritte-resembling head, the latter seemingly smoking itself in the pipe, has the effect of an ironic replica of the light which one is said to see when engaged in deep thought.
"Consideration of a manic, absent-minded philosopher can prompt thoughts of a self-contained intellectual world, in the same way that the smoker here is the prisoner of his pipe."
René Magritte

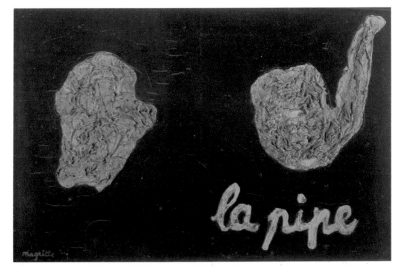

The Pipe, 1926
This is the only picture in which Magritte experimented with the application of paint. Instead of using a thin coat, he applied the green paint so thickly that it stands out three-dimensionally from the canvas. Despite the relief-like tangible nature which this gives the pipe-form, however, it is still no pipe.

The Empty Mask, 1928
"The words which serve to characterize two different objects do not of themselves reveal what it is that distinguishes one of the objects from the other."　　　René Magritte

dream, thought, bodily desires and aspirations are so often united, has presented market-orientated plagiarists with an inexhaustible "treasure trove" into which they have dipped with neither restraint nor scruple in order that they might better further the sales of some product or other. Pictures by the painter of the metaphysical and the surreal have so often been copied and exploited for primitive, exclusively commercial purposes that one sometimes has the direct impression that he took modern reality as the model for his work. Magritte's poetic world seems to have anticipated the world of today, in which journalists are confused with men of letters and foolish daubers with painters.

The Philosophical Lamp (ill. p.69) illuminates two absurd sights, the first a closed circle of smoke with mouth, pipe, and nose constituting a single entity, the second formed by the candle, the wax of which, while soft and already melted at its lower end, is increasingly firm towards the burning wick, towards the light. The subversive humour with which Magritte destroys what one might suppose to be the most reliable certainties finds unusually clear expression in this picture. After the fashion of Dada, in the spirit of the Marx brothers or even in the spirit of true philosophy, he had no time for the presentation of objects or ideas in such a manner

Magritte at work on his painting *The Empty Mask*, 1928

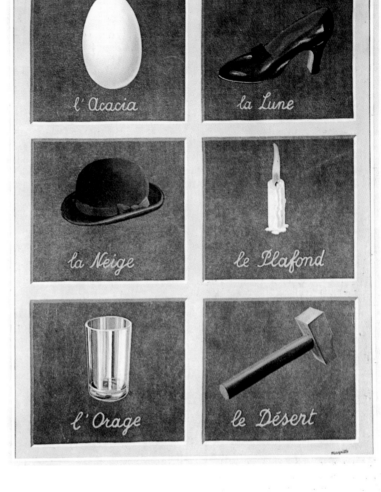

The Interpretation of Dreams (The Acacia, The Moon, The Snow, The Ceiling, The Storm, The Desert), 1930
Magritte's combination of objects and labels could be understood as an infiltration of the existing order, one which can and should prompt quite unexpected associations.

as to suggest they were inaccessible to any form of analysis, above thought, and entrenched behind utopias and principles. His intention was merely to undermine the foundation of things, to question quite seriously that which is serious itself, as simply as possible, without any great fuss, harmlessly and almost anonymously. He overloaded the visible manifestation of the object to such an extent that it became more than obvious, thereby enabling its very own innermost mystery, its deceptive charms and seducing powers, to develop out of its own self. In using images and words in his function as a painter, he was bringing the appalling banality of things to light, turning the most common and everyday situations with which people are confronted into their opposite – and this in every moment, so to speak.

Everything which is good is also simple – a viewpoint that also holds true for Magritte's art. He possessed the talent to slip between objects and their depiction, but also between pictures and words, between the three-

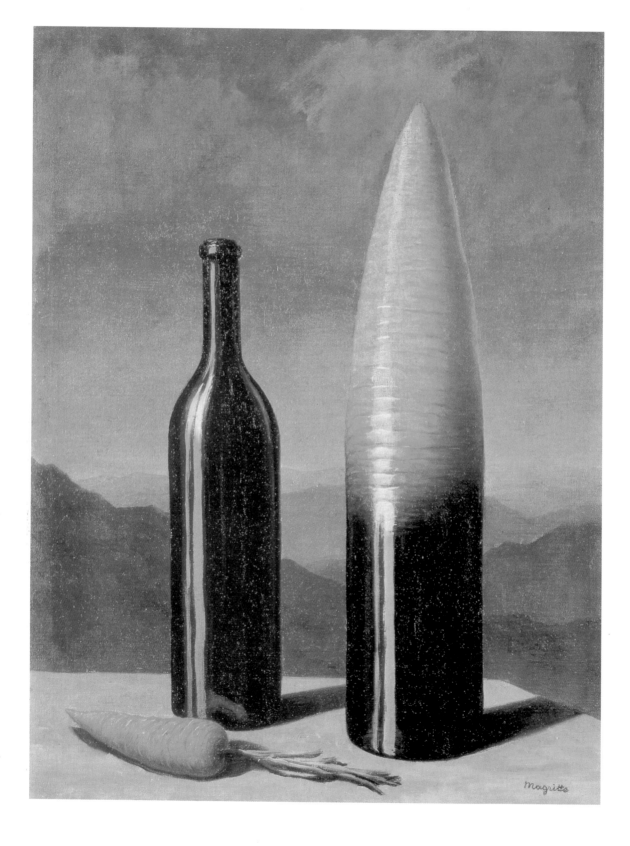

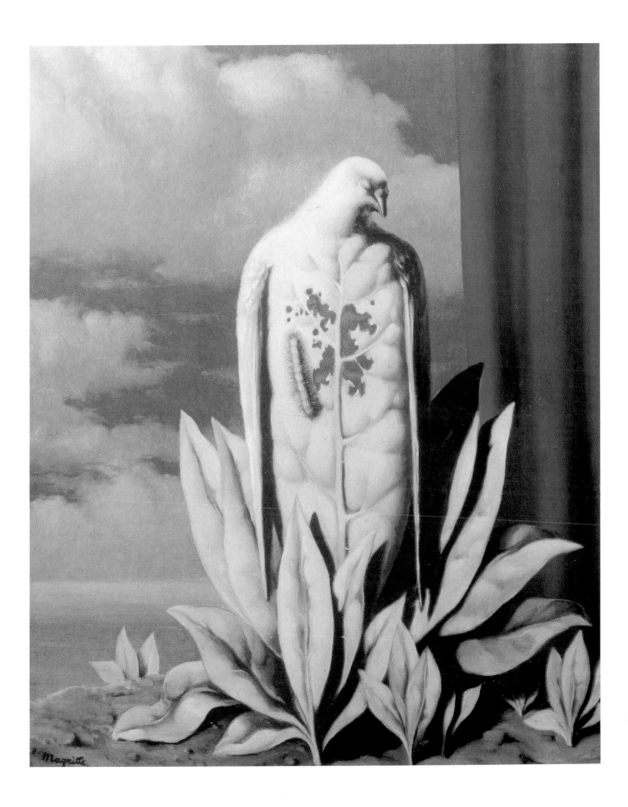

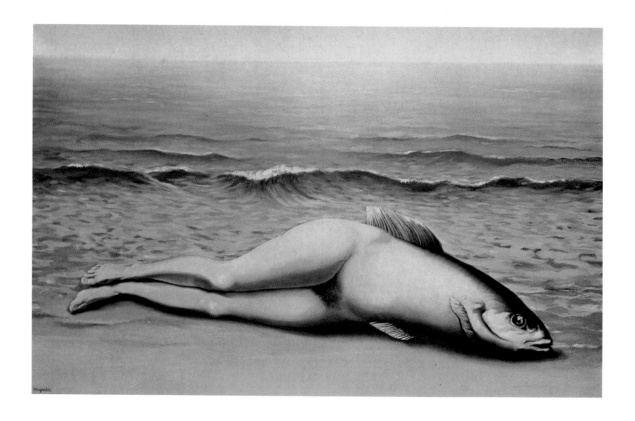

Collective Invention, 1934
A back-to-front mermaid lying stranded upon the seashore – not with the tail of a fish and a woman's upper body, as we normally encounter her in fairytales and myths, but with the head of a fish and a human lower body.

ILLUSTRATION PAGE 72:
The Explanation, 1954
A painted bottle and a carrot are united to form a new, surreal signifier.

ILLUSTRATION PAGE 73:
The Flavour of Tears, 1948
"The sight of a felled tree simultaneously causes pleasure and gives rise to sadness."
René Magritte

dimensional form of the figures and the graphic appearance of the letters. It is here that Magritte subtly and maliciously misleads the observer, making use of the freedom that painting offers to allow the very *lack* of relationship between what can be seen and what can be read, between seeing and reading, constantly to prevail. Furthermore, he turns this negation of a relationship inside out, rendering it a positive force, subversive poetics, one in the position to unsettle the imaginary itself. Most people, upon thinking of a mermaid, imagine a figure with a woman's upper body and the tail of a fish below. If this conception is turned on its head, if someone paints a fish-woman instead of a woman-fish, one might think this no great step, since we are anyway moving here in the realm of the unreal, in the sphere of the imagination. And yet the observer is quite clearly confronted in *Collective Invention* (ill. p. 74) – in contrast to that which is called collective imagination – with an unreal situation, one which strikes and confuses in a different way to customary unreality or pure fantasy. Magritte is no visionary, no dreamer; he is an inventor, a thinker. He does not seek to lead us into some other, distant world. Rather, he would shed light upon the incoherence that is common to our habitual ways of thinking, be they imaginary and unconscious, as in the case of the mermaid, or more conscious and more symbolic, as with *The Interpretation of Dreams* (ill. p. 71), a work which separates images and words very clearly,

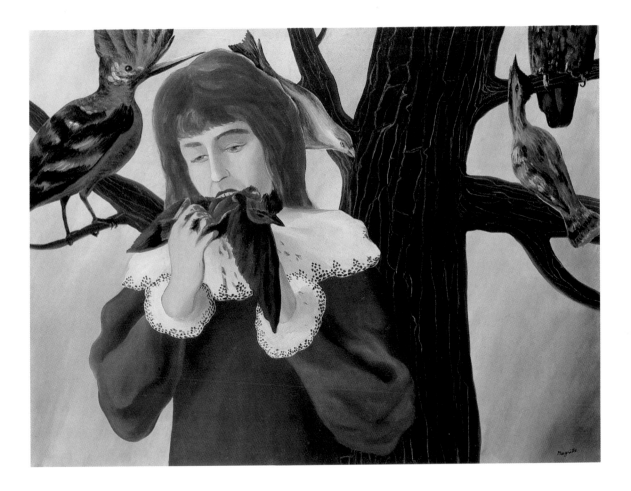

Pleasure, 1927
Magritte has intensified his pictorial pleasure
from confusion to shocking depiction: here
we are confronted with a girl in a white lace
collar who, enjoying a sheltered upbringing,
is holding a bird in her hands, into which she
is apparently quite composedly biting, as the
blood runs down. The idea behind the picture
is not so much the cruel element in children
as the desire for what is unbelievable.

thereby confronting the observer's intellect with the arbitrary nature of
our signs and codes. His relentlessness has a frightening element to it: ac-
cording to Magritte himself, the act of painting *Pleasure* (ill. p. 75) was
accompanied by a not altogether harmless tendency towards mental
cruelty. It is quite possible that this aspect disturbs. Is the painter not
preferring an artificial, abstract universe to life as he has experienced it?
A world in which life is invented, is inorganic, is populated by new,
strange creatures: the body of a leaf-bird, being devoured by a caterpillar
(*The Flavour of Tears*, ill. p. 73), or a young girl biting with bared teeth
into a living bird, surrounded by other birds, apparently further candi-
dates awaiting the same fate – if not impatiently, then at least with a cer-
tain fearlessness and stupid curiosity? The cruel art of painting can reveal
the full mysterious force of objects, describe the lightness of a dream
with the aid of mighty boulders (*The Art of Conversation*, ill. p. 76), or
concentrate the history of centuries in the depiction of two chairs, one of
them of gigantic proportions and in existence since time immemorial, the
other modern in style and minute in size... (*The Legend of the Centuries*,
ill. p. 77).

Far from being concerned with establishing a hierarchical relationship
between model and reproduction, a relationship in which the one should
be equivalent to the other, Magritte is instead playing a game of differ-

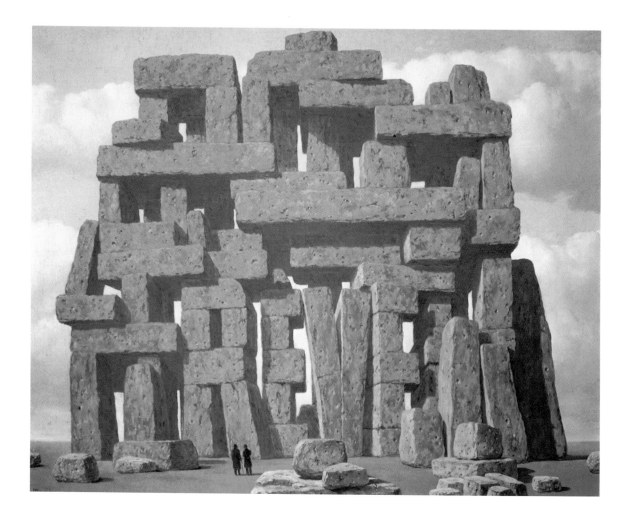

The Art of Conversation, 1950
"... within a landscape from the beginning of
the world or from the battle of the giants
against the gods, two tiny figures are speaking
with each other – an inaudible conversation,
mere murmuring, instantly swallowed up by
the silence of the stones, the silence of the
wall, the mighty blocks of which tower over
the two mute chatterers..." Michel Foucault

ences, not only those between sequences of writing and images, but
also quite fundamentally the difference in the realm of the visible, pulling
out all the stops and setting in motion the proliferating endlessness of
every trick and every illusion. Two chairs suffice to establish a series;
a small difference suffices to stage the whole infinite game of the dif-
ferences between the differences. This game takes over the entire area of
the picture, so as to reduce it to what it is, namely an abstract reality,
"something in the mind", according to Duchamp, "nothing but visible
thought", as Magritte would say. Both artists share the view that the
painted work cannot be separated from thought, that there not only is a
knowledge existing in the gesture of the painter but that this knowledge
goes beyond the technical level of the work, actively penetrating the in-
nermost layers of the aesthetic. The painter's knowledge is not merely
simple technical ability, but is also an intellectual ability: in other words,
it contains a moment of reflection.

Magritte, with Vincy and Duchamp, believed that every image has a
sense, a meaning; thus, a work cannot be reduced to the mere arrange-
ment of materials. The material basis creates an immaterial effect which,
while it cannot be reduced to the techniques employed, cannot be separ-

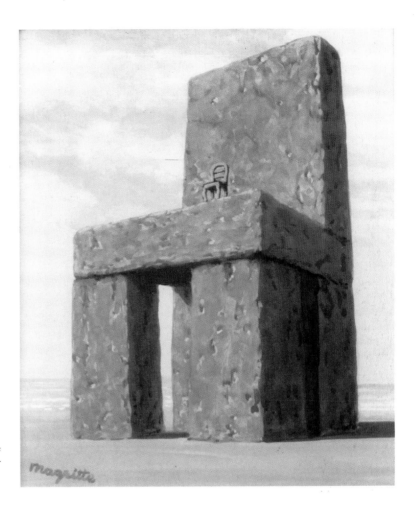

The Legend of the Centuries, 1948
Homage to the lack of moderation displayed
by Victor Hugo, who wrote his work with the
intention of rivalling the Bible, wishing to re-
cord the history of Paradise Lost up to the
twentieth century and beyond...

ated from them either. This effect cannot come about outside of or with-
out the techniques. The meaning of the work, its aesthetic effect, bears
the trait of the "as if"; that is, its meaning emerges through its effect upon
the body and intellect of the observer. For his part, however, the observer
is compelled, if he is to experience the effect, to grasp the difference be-
tween the technical level, which is the basis of the work, and the aesthetic
level. Even if thought – a matter of words and concepts – is of its very
nature invisible, the fact remains that, within the context of painting, the
invisible – meaning – falls in upon itself in that moment in which the
visible disappears. The art of painting expresses the invisible by means of
the visible, thoughts by means of images. People have often *abstractly*
theorized about this form of articulation. Magritte's genius doubtless lies
in the fact that he *concretely* reflected it, made it the subject of his pic-
tures themselves. If he is to imagine the difference between what is vis-
ible and what is thought in his painting, the painter must render these
thoughts visible, must render them so that they can be perceived by the
eye. It is for this reason that Magritte introduced words into his pictures,
uniting that which can be seen and that which can be read on one and the
same surface.

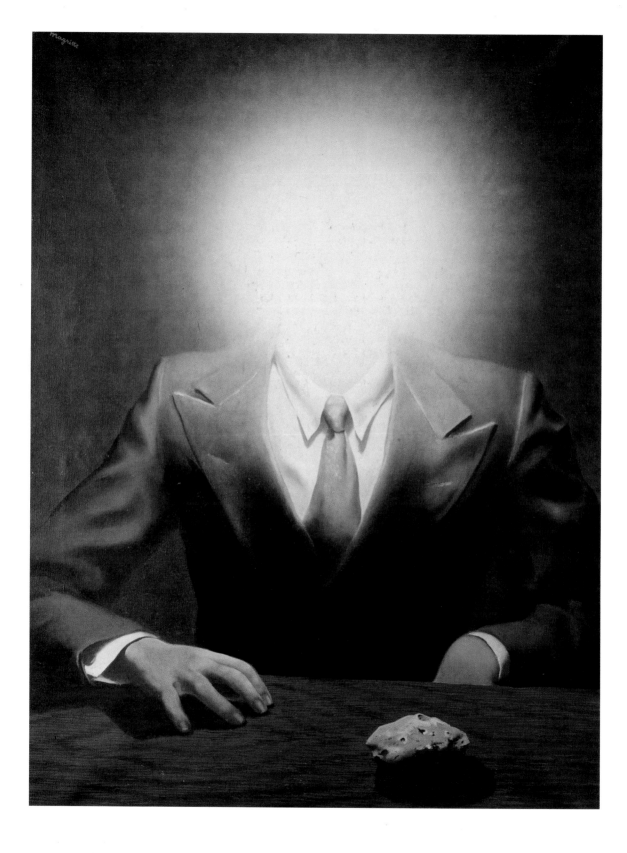

Thought Rendered Visible

Space thus emerged between the visible and its manifestations, on the one hand, and the invisible and thought, on the other – space for a reflective alliance between the images and their meaning. Magritte included this pact of uncertainties and wonders in his pictures. It is a pact with the devil, however, since the signatories are so incompatible and so heterogeneous in nature that a merging of or clash between the two does not even give rise to contradiction. The squaring of a circle at least requires the presence of two geometrical figures, yet there exist no points of reference or links whatever between what one says and what one sees, between the logic of discourse and the figuration of what is visible. One is quite aware that the sun is no big red disc some two hundred metres away; nevertheless, there are some summer evenings when it at least seems to be such.

A mysterious element is present in the most natural manifestation of objects, invincible and totally resistant to established concepts. It radiates the impossibility of reducing the visible to the *logos*, possessing precisely that all-encompassing dimension that distinguishes the world of Magritte's pictures, the anchorage which he never relinquished. One could even say that he settled upon this very heterogeneity of reflection and reflex, of speculation and mirror-image, in order to resolve the mutual exclusion of seeing and thinking on the metaphysical surface of the canvas. His works display the unconsidered within the visual. The bells worn by the horses in Charleroi in the first half of the century, when portrayed floating in mid-air and greatly enlarged, reveal an exciting magic and poetry (*The Voice of the Winds*, ill. p. 87). The objects of painting are free of the ties which exist between things in the everyday world. On the contrary, they possess an artificial power and a more than physical potential, demonstrating an urge to drift away such as is characteristic of thought itself – with the proviso that thought is nothing other than an active and intensive confrontation with the unthinkable. The word "magic" comes from the Persian, and has the same root as the German word *mögen* (in turn related to the English verb form "may" as in "maybe", in the sense of "possibly be able to"). It characterizes the possibility of penetrating every form, every identity, without submitting to a binding association with any of them. Is the body of the dove turning into clouds? Or are the fantastic clouds becoming a bird? *The Large Family* (ill. p. 86) of poetic forces refers to the fusion of heavenly powers, the fusion of clouds and birds, while *The Discovery of Fire* (ill. p. 80) is surely captivated by the birth of its own mystery, since the flames which we see painted here are feeding upon something quite impossible. In Magritte's picture *Manet's Balcony* (ill. p. 82), the place of the gentleman in black and the young

Study for: *The Pleasure Principle (Portrait of Edward James)*, 1936

The Pleasure Principle (Portrait of Edward James), 1937
While working on the portrait of Edward James after a photograph by Man Ray, Magritte substituted the explosion of light produced by a camera flash device for the face of his model, thereby – as so often – mocking and demonstrating the principle of unreality lying behind a picture.

79

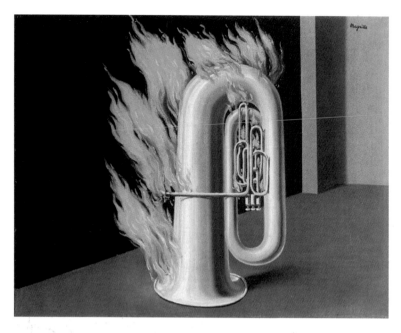

The Discovery of Fire, 1934/35
Fire as mystery, as a force devouring every-
thing before it without exception. Fire has al-
ways had a central significance and fascina-
tion, in every culture and every age. The
flames appear to be taking their course quite
unhindered, as if the tuba were made of wood.

ladies dressed in white has been taken by the symbols of their death. Cof-
fins have adopted the sitting or standing poses assigned the figures by
Manet. Does the picture not refer to the inorganic, death-bringing charac-
ter of painting? Is Magritte not practically insisting upon this – and there-
fore simultaneously upon the freedom and the very special nature of life
that is inherent in art? There is no flesh, no sex, in painting, yet this de-
sexualized world is imbued with a quite different kind of sensuality and en-
ergy. Leaving the realm of sorrow and joy, we enter the world of creative
works and aesthetic inventions. Accordingly, *The Seducer* (ill. p.89) is no
ship; rather, the sea looks like a ship. The same is true of the pictures *Gol-
conda* (ill. p.84) and *The Month of the Grape Harvest* (ill. p.85), where
Magritte is playing with the concept of multiplying identical figures, in
order to demonstrate that the social identity of people cannot appeal to a
solid foundation. Fantômas could be hiding in each of them, in some, in
only one, or in none. Poetry can be everywhere and nowhere, but one
must first be placed in the position and discover the prerequisites neces-
sary for being disturbed and confused – by a visual experience, for ex-
ample – before one can then sense the depths, the bottomless nature, lurk-
ing in the deepest core of things, in those principles that seem most sound.

Magritte's art is the revenge of poetry upon the power of blind techno-
logy, the revenge of *philo*sophical thought, of questioning, open thought,
in contrast to firmly established certainties and dogmas of whatever incli-
nation. The "leaders", the demagogues, the prophets of a radiant future,
are nothing else than dangerous Cicerones, their mouths spewing forth
not thoughts or words but fire and lead. Magritte's picture *The Cicerone*
(ill. p.81) lends a subversive political aspect to the famous jointed dolls
of de Chirico's metaphysical painting. While the mystery of the world is
ultimately invincible, it is nonetheless only too vulnerable to greed and
the lust for power. Life, the greatest mystery of them all, is threatened
and damaged by forces from science and politics, forces regarding them-
selves as chosen and empowered to supervise and run this life – that is,

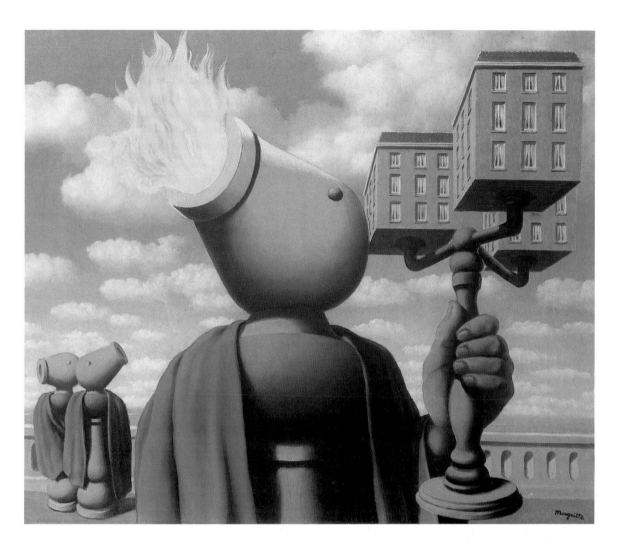

The Cicerone, 1947
The verbose and imperious guide sets both direction and path. A reflective pause would not correspond to its structure. Under its domination, technology and politics are accordingly characterized by the same absurd barbarism.

Edouard Manet:
The Balcony, 1868/69

Perspective II: Manet's Balcony, 1950
The figures in Manet's picture have been replaced in that of Magritte by coffins; otherwise, the scene remains unchanged. The place of the living is taken by dead objects, which – shockingly – would seem to represent the humans equally well.

to dominate and manipulate it. The picture *The Pleasure Principle* (ill. p. 78) is a portrait of Edward James, the English collector, after a very fine photograph by Man Ray. A simple explosion of light, a violent electric flash, has taken the place of the face, of the revealed soul. Magritte has substituted the simple truth of his art for the effects of *re*presentation, *re*production, and *re*petition typical of this technique. He is demonstrating that the photographic snapshot, rather than recognizing reality, in fact represents a mechanical operation and manipulation such as transforms light and shadow into a deceptive illusion. He is conducting a dialogue, not with the head of Edward James (who, incidentally, was the model for *Not To Be Reproduced* (ill. p. 15), too) but rather with the art of photography. Magritte himself was a first-rate photographer. He is uncovering the mystery of photographic reproduction, giving it an ironic interpretation by placing the stone on the other side and exchanging the position of the right and the left hands, at the same time shifting them very slightly.

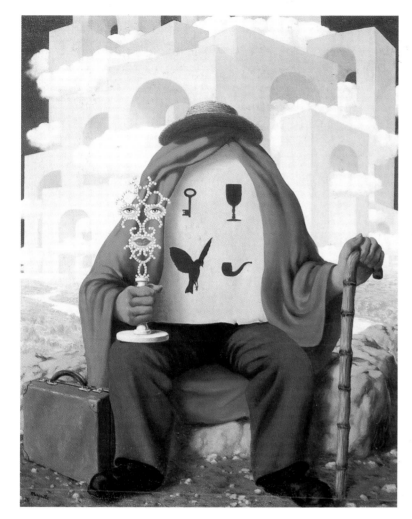

God on the Eighth Day, 1937

The Liberator, 1947
The pictures of a key, a bird, a pipe and a glass, portrayed in isolation on a board, have the effect of mysterious, enigmatic signs. We can name them individually; however, their deeper significance is hidden on the other side of the depiction, within the imagination of the respective observer.

Headlessness has been inflicted upon the model in a portrait that is not "drawn forward", as the Latin root – *protrahere* – says, but seems rather to have been pushed back, driven by the canvas through the canvas itself, through the light of what is visible, which always has the tendency more to hide than to uncover and reveal. Magritte never ceased in his concern to demonstrate that what we see is in fact concealing something from us, while what is invisible is for its part incapable of remaining hidden, its nature being such that it perforce cannot be shown. It is even possible to show that it cannot be shown, by ordering the visible figures in such a way that the limits of what is visible can be appreciated. Painting alone cannot cross these limits, however. *The Pleasure Principle* (ill. p. 78) portrays the principle of painting as a sensory statement full of abstract realities, the inverting and perverting of the customary world in favour of the more real world – not that world inhabited by those who lay down commandments and prohibitions, but rather a mysterious and unimaginable

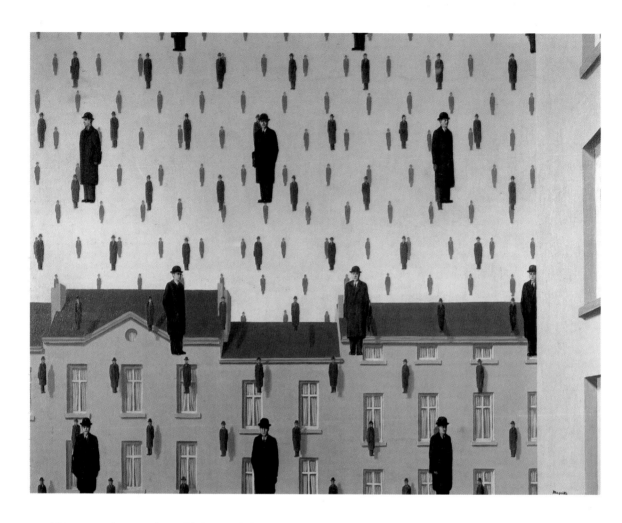

world, an appeal, a promise, which art and thought seek to answer and fulfil. Asked by Charles Flamand, the journalist, if he often thought of death, Magritte replied: "No, not more often than of life."

In his own words, Magritte lived "like everything else" *in* the mystery of the world. Instead of seeking a more or less new and original manner of painting, or inventing new techniques, he preferred to get to the bottom of things, to use painting as the instrument of thinking and philosophical wisdom, as a means of recognition inseparably bound up with mystery, with the inexplicable. Magritte led an unobtrusive and bourgeois life. He only bore the intolerably commonplace character of modern life by slipping apparently effortlessly between habits of speech and vision, then to trace them back quite calmly and casually to that passionate absoluteness of mystery which is closed to popular judgements and perceptions. After due consideration, he decided that he – like Marcel Duchamp – could only be an "an-artist", a painter breaking with the superficial sensualist platitudes that lead us to believe in the existence of flesh and blood where there are in fact merely paint and lines, or even nothing more than "a heap of rags on the wall", as Magritte wrote to Rauschenberg. He despised artists who became prisoners of their talent and virtuosity, detested an ability that was merely technical and fixated upon ma-

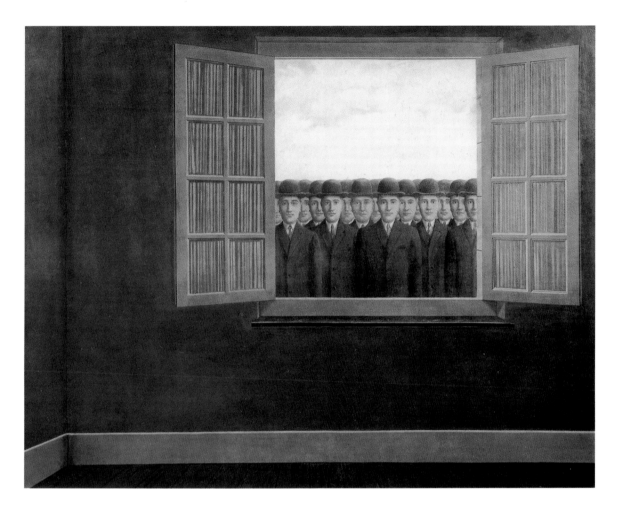

terials. His constant and sole concern was with thought in pictures, with no preconceived ideas, no concepts – thought in an exclusively visual sphere, one nevertheless stimulated by the intellect and metaphysics.

We do not possess the words with which to express and imagine the mystery of "being", but since Magritte we do have pictures showing how much we lack the thoughts, how much the mind aims at the impossible, but also that it is nonetheless possible never to have to do without the impossible. Will we ever be capable of internalizing Magritte's work, capable of *The Labours of Alexander* (ill. p. 88)? Will man one day be master of his destiny? There are sufficient reasons for scepticism. Yet with the help of Magritte's pictures, we can at least survive in thought beyond despair and hope, by experiencing the mystery of meaning as inseparable from – but not reducible to – the senses. Meaning develops from a multitude of sensory powers: those of the hands, the ears, the mouth (when speaking, of course, and not when eating). But man cannot maintain that he has control of all these powers. Rather, he realizes himself in them all in linking them to one another. When you *see*, you are not reading, and nor are you listening, yet without the complex of the other senses, or at least certain other senses which support sight – others being excluded through an internal process – you would be unable to see any-

The Month of the Grape Harvest, 1959
Here too, as in *Golconda*, appear the anonymous, interchangeable, bowler-hatted men. They are hermetically obstructing the view out of the window, thereby acquiring an almost threatening expression despite their passivity.

ILLUSTRATION PAGE 86:
The Large Family, 1963
Is the body of the dove turning into clouds? Or are the fantastic clouds becoming a bird?

ILLUSTRATION PAGE 87:
The Voice of the Winds, 1928
The horses in both Charleroi and Brussels once wore bells around their necks, the sound of which left a lasting impression upon the painter. In allowing these bells to float freely in mid-air, exposed to the winds, he is imparting pictorial embodiment to audible perception.

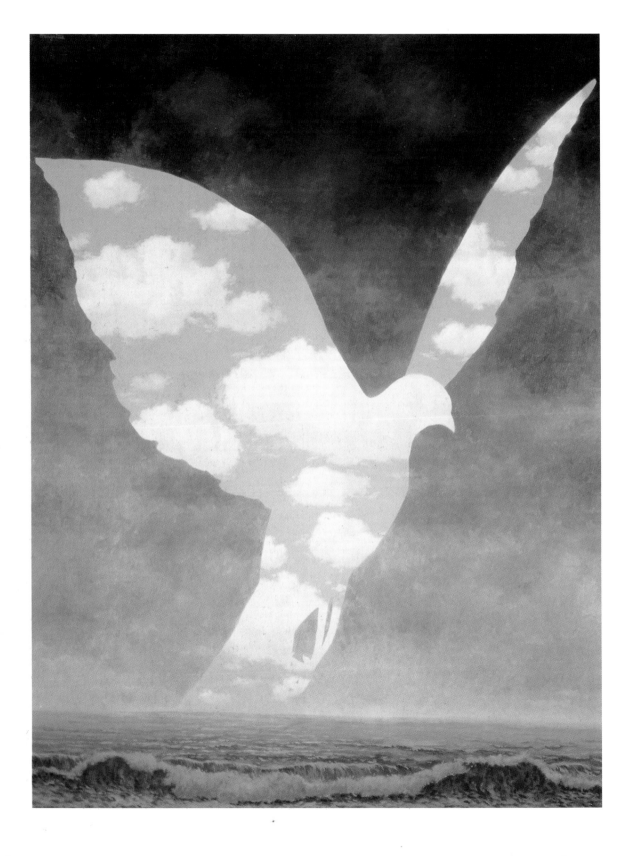

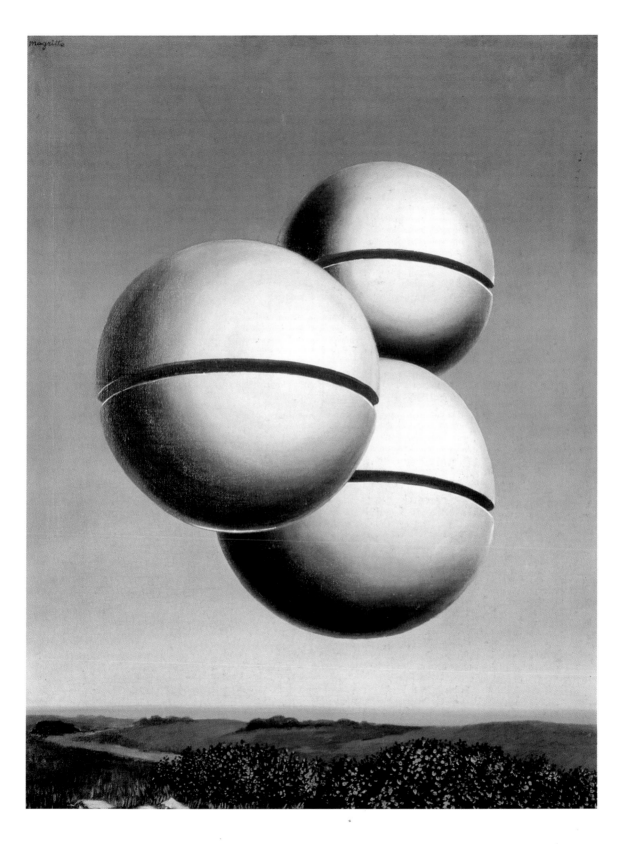

The Labours of Alexander, 1967
The root of the freshly felled tree is reaching for the axe, holding on to it. Once again, it is artistic poetry which renders possible the impossible.

thing. None of our senses can function on its own. Not until sight includes the body do we really see; yet the unit "body" is by no means at the service of sight alone. Rather, it represents an irregular multiplicity, a field of the most different forces and possibilities which gradually releases one potential after another.

Magritte's art demonstrates to the eye and the intellect the highly uncertain character of everything making up the realm of the visible. He enrols in the register of the visible, offering the eye of the observer certain movements and associations such as have settled in the depths of the body. However, this revelation of that which is hidden and latent never takes place in a manner contradictory to visual perception. On no account did Magritte allow the technical level of his work to take on a purely aesthetic surface effect. He considered it neither possible nor desirable that the material preconditions of a work should disturb the utterly immaterial, incorporeal meaning which they have produced. It is not the painter's concern to deny physical or socio-psychological determinedness; rather, he wishes to rob it of its meaning in favour of an artificial,

poetic, new meaning which provides fertile soil for the uncertain, the mysterious.

The meaning inherent in Magritte's work touches directly on the "Anarchy of the senses" to which Rimbaud's poetry bears witness. Those forces which support the visible remain concealed behind it; only painting is capable of rendering them visible. This process does not simply happen: instead, painting actively sets in motion a metamorphosis by means of which it changes and alters these forces solely through the fact that it is depicting them. What matters, Magritte liked to say, is not that the copy should be similar to the model, but that the model should have the courage to resemble its copy. Put another way, it is essential to understand that art does not take up a meaning already inherent in reality; quite the reverse, it is art which confers meaning upon reality by opening up previously undreamt-of paths which – despite and because of its abstract nature – present life with new horizons. Magritte's power and strength lie in his ability to maintain the demand for and necessity of sense in a world which has ceased to be conscious of this desire.

The Seducer, 1953
The observer is seduced by an idea which is poetic and plausible at the same time, that of an object taking on the substance of the material in which it feels itself at home. Here, accordingly, the ship is constructed of water, thereby becoming a kind of "castle in the air" of Magritte's painting and world of ideas.

René Magritte 1898–1967: Chronology

1898 21st November: René Magritte is born in Hainaut, Belgium.

1900–1909 A crate next to his cradle; the recovery of a captive balloon from the roof of his parents' house; the vision of an artist engaged in painting the cemetery where the young René and a little girl are playing – three childhood recollections of Magritte's.

1910 The family moves to Châtelet. Magritte attends a painting course.

1912 His mother commits suicide, throwing herself into the River Sambre.

1913 Lives with his father and two younger brothers in Charleroi. Attends the grammar school there; develops a great enthusiasm for the Fantômas films and reads Robert Louis Stevenson, Edgar Allan Poe, M. Leblanc and G. Leroux.

1916 Enrols in the Académie des Beaux-Arts in Brussels. His family also moves to Brussels in the following year.

1918–1920 First pictures, initially in the Cubist, then in the Futurist manner. Makes the acquaintance of Pierre Bourgeois, the poet, who is impressed with Magritte's work; Magritte will later provide illustrations to Bourgeois' poems. Meets E. L. T. Mesens. First designs for posters and advertisements.

1922 Marries Georgette Berger, with whom he first became acquainted when fifteen years old, meeting her again in 1920. She also becomes his model. *Song of Love* by de Chirico, a copy of which Marcel Lecomte, the poet, shows him, constitutes an important artistic turning-point for Magritte. Together with Victor Servranckx, he draws up the manifesto "Pure Art. Defence of the Aesthetic". Works as a textile pattern designer.

1924 His "Aphorisms" are published in the magazine *391*. He is earning his living from designs for posters and advertisements.

1925 The Brussels gallery "Le Centaure" offers him a three-year contract. He edits the magazines *Œsophage* and *Marie*, together with Mesens, Arp, Picabia, Schwitters, Tzara and Man Ray.

1926 A period of intensive work, resulting in sixty pictures within the space of one year. Considers *The Lost Jockey* his first successful Surrealist work. Links with Goemans, Nougé, Scutenaire and Souris. The group regularly meets with Lecomte and Mesens.

1927 First one-man exhibition in the gallery "Le Centaure" (April). Magritte and his wife follow Goemans to Paris, where they settle in Perreux-sur-Marne. Magritte participates in the activities of the Surrealists, establishing a close friendship in particular with André Breton and Paul Eluard.

1928 Exhibition in the Brussels gallery "L'Epoque" (January). Participates in the first group exhibition by the Surrealists at the Galerie Camille Goemans, Paris. First experiments in film with Paul Nougé.

1929 Vacation in Cadaquès with Dalí, Miró, Buñuel, Eluard and Goemans. Publishes "Words and Images" in the magazine *La révolution surréaliste*, the cover of which bears a photomontage depicting members of the group.

1930 Participation in the exhibition of Surrealist collages in the Galerie Camille Goemans. Returns to Brussels.

The shadow and his shadows, 1932

René Magritte's parents

Adeline Magritte and her son René, 1899

René Magritte, 1930

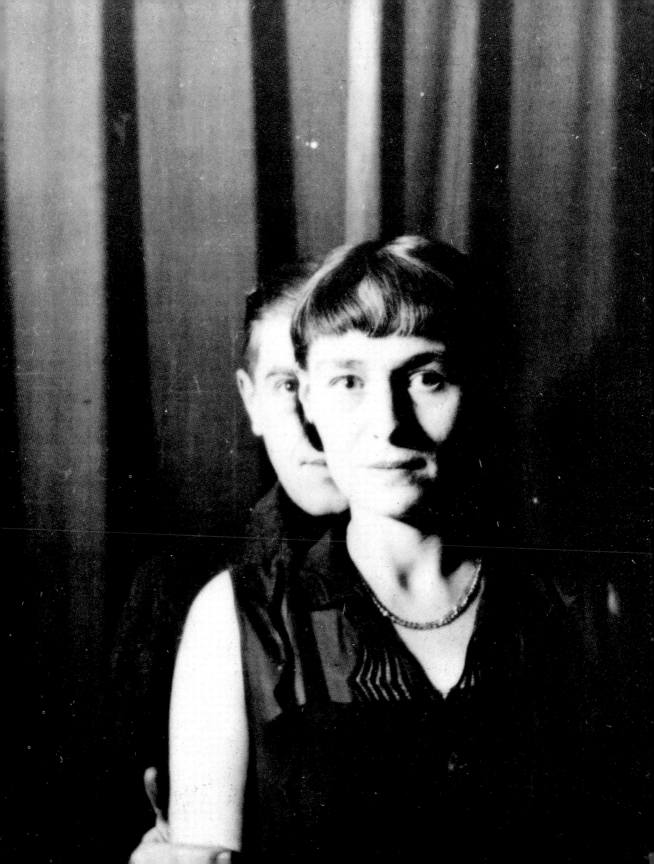

From left to right: Mesens, Magritte, Scutenaire, Souris, Paul Nougé, Irène Hamoir, Marthe Nougé and Georgette Magritte, 1934

René Magritte, c. 1960

René Magritte, Marcel Duchamp, Max Ernst and Man Ray in Paris, 1960

1933 59 works are shown at the Palais des Beaux-Arts, Brussels. Participates in the Surrealist exhibition at the Paris gallery "Pierre".

1936 First New York exhibition at Julien Levy's. Participation in the London "International Surrealist Exhibition" and "Fantastic Art, Dada and Surrealism" in New York. Shuzo Takiguchi, the Japanese poet, publishes poems inspired by Magritte's pictures in "L'Echange surréaliste".

1938 A Surrealist exhibition is organized by Marcel Duchamp at the Galerie des Beaux-Arts. Magritte's works exhibited in London.

1940 Drawing and writing for Surrealist magazines such as *L'Invention collective* and *La chaise de sable*.

1941 Exhibition at Galerie Dietrich, Brussels.

1945 Participation in the "Tableaux, dessins, collages, objets, photos et textes" exhibition at the La Boétie publishing house, Brussels. Pays homage to James Ensor in the magazine *Le Drapeau Rouge*.

1945–1948 Paintings in the style of Renoir (so-called "vie-heureuse" or "plein-soleil" period).

1946 Twelve drawings for Eluard's "Les nécessités de la vie et les conséquences des rêves".

1947 Exhibition in New York at the Hugo Gallery, and in Brussels at Lou Cosyn's.

1948 77 illustrations for Lautréamont's "Songs of Maldoror". Exhibition of oils and gouaches at the Galerie du Faubourg, Paris;

Paul Nougé

André Masson

E. L. T. Mesens

René Magritte, c. 1960

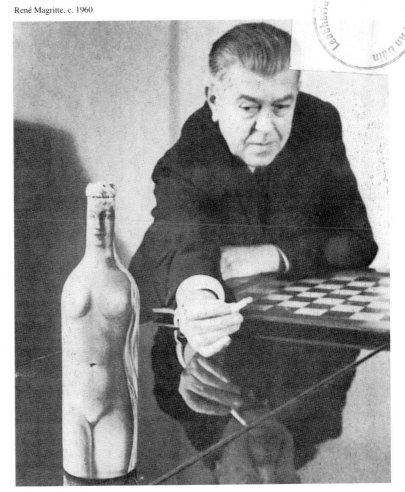

his friends characterize them as the fruits of his "époque vache" (Cow Period).

1952 Publishes the first number of *Carte postale d'après nature*, a magazine initially appearing in the form of a postcard with a picture and a text.

1953 Executes *The Enchanted Realm* wall-painting, consisting of eight pictures, for the gaming room of the Knokke-le-Zoute casino. First exhibition in Italy (Rome) and at Alexandre Iolas' in New York.

1954 First retrospective at the Palais des Beaux-Arts, Brussels. Provides an autobiographical sketch for the catalogue.

1956 Awarded the Guggenheim Prize for Belgium.

1957 Executes *The Ignorant Fairy* wall-painting for the Palais des Beaux-Arts, Charleroi.

1960 Regular contributions to the Belgian magazine *Rhétorique*, which dedicates its ninth issue to him.

1961–1962 Travelling exhibition with Tanguy in the USA.

1965 Retrospective at the Museum of Modern Art, New York. Patrick Waldberg dedicates a monograph to him.

1967 Exhibition at the Museum Boymans-van Beuningen, Rotterdam, and the Moderna Museet, Stockholm. Wax models for eight sculptures after his own pictures, cast under the supervision of Berrocal in Verona. Magritte dies on 15th August in Brussels.

List of Plates

38
The Natural Graces, 1967
Les grâces naturelles
Bronze, height: 107cm
Patrimoine culturel de la Communauté française
de Belgique

39
The Companions of Fear, 1942
Les compagnons de la peur
Oil on canvas, 70.4 x 92cm
Brussels, B. Friedländer-Salik and V. Dwek-Salik
Collection

40
The Giantess, 1929/30
La géante
Watercolour on paper, cardboard and canvas, 54 x 73cm
Cologne, Museum Ludwig

41
The Tomb of the Wrestlers, 1961
Le tombeau des lutteurs
Oil on canvas, 89 x 117cm
New York, private collection

42
The Domain of Arnheim, 1938
Le domaine d'Arnheim
Oil on canvas, 73 x 100cm
Private collection

43 top
Giorgio de Chirico:
Song of Love, 1914
Le chant d'amour
Oil on canvas, 73 x 59.1cm
New York, Collection, The Museum of Modern Art,
Bequest Nelson A. Rockefeller

43 centre
Drawing from the "Pour illustrer Magritte" book,
Les Lèvres Nues (Bare Lips), April 1970

43 bottom
The Eminence Grise, 1938
Photograph, 11 x 7.5cm

44
Beautiful World, 1962
Le beau monde
Oil on canvas, 100 x 81cm
Private collection

45
Carte Blanche, 1965
Le blanc-seing
Oil on canvas, 81 x 65cm
Washington (DC), The National Gallery of Art,
Collection Mr. and Mrs. Paul Mellon

46
The Ready-Made Bouquet, 1956
Le bouquet tout fait
Oil on canvas, 166.5 x 128.5cm
Private collection

47
The Blank Page, 1967
La page blanche
Oil on canvas, 54 x 65cm
Private collection

48
Illustrations for "Les nécessités de la vie" by
Paul Eluard, 1945
Drawing
Courtesy Galerie Isy Brachot, Brussels

49 top
Transfer, 1966
Décalcomanie
Oil on canvas, 81 x 100cm
Formerly Perelmann Collection

49 bottom
Duane Michals:
Double portrait of the artist, 1965
Portrait double de l'artiste
Photo: Courtesy Galerie Isy Brachot, Brussels

50
The Rape, 1934
Le viol
Oil on canvas, 25 x 18cm
Courtesy Galerie Isy Brachot, Brussels

51
Natural Knowledge, undated
La connaissance naturelle
Drawing on a beer mat, 9.5 x 9.5cm
Courtesy Galerie Isy Brachot, Brussels

52
The Acrobat's Exercises, 1928
Les exercices de l'acrobate
Oil on canvas, 116 x 80.8cm
Munich, Staatsgalerie moderner Kunst

53
Intermission, 1927/28
Entracte
Oil on canvas, 114.3 x 161cm
Private collection

54
Dangerous Liaisons, 1926
Les liaisons dangereuses
Oil on canvas, 72 x 64cm
Private collection

55
Eternal Evidence, 1930
L'évidence éternelle
Oil on five canvases of different sizes,
26 x 16, 22 x 28, 30 x 22, 26 x 20, 26 x 16cm
Houston (TX), Courtesy The Menil Collection

56
Homage to Mack Sennett, 1937
En hommage à Mack Sennett
Oil on canvas, 73 x 54cm
La Louvière, Collection of the City of Louvière

57
Philosophy in the Bedroom, 1966
La philosophie dans le boudoir
Gouache, 74 x 65cm
Private collection

58
The Well of Truth, 1967
Le puits de vérité
Bronze, 81 x 42 x 25.5cm
Private collection

59
The Red Model, 1937
Le modèle rouge
Oil on canvas, 183 x 136cm
Rotterdam, Museum Boymans-van Beuningen

60
Georgette and René Magritte in Perreux-sur-Marne, 1928
Photo, 11 x 7.5cm
Courtesy Galerie Isy Brachot, Brussels

61
Attempting the Impossible, 1928
La tentative de l'impossible
Oil on canvas, 105.6 x 81cm
Private collection

62
The Magician (self-portrait with four arms), 1952
Le sorcier (autoportrait aux quatre bras)
Oil on canvas, 34 x 45cm
Courtesy Galerie Isy Brachot, Brussels

63 top left
A Happy Touch, 1952
La main heureuse
Drawing, 35 x 24cm
Brussels, private collection

63 top right
A Happy Touch, 1953
La main heureuse
Oil on canvas, 50 x 65cm
Private collection

63 bottom
The Listening-Room, 1958
La chambre d'écoute
Oil on canvas, 38 x 45.8cm
Private collection

64
The Lovers, 1928
Les amants
Oil on canvas, 54.2 x 73cm
Brussels, Private collection

65 left
The White Race, 1937
La race blanche
Oil on canvas, 39 x 29.5cm
Courtesy Galerie Isy Brachot, Brussels

65 right
The White Race, 1967
La race blanche
Bronze, height: 58cm
Patrimoine culturel de la Communauté française
de Belgique

66
The Human Condition, 1935
La condition humaine
Oil on canvas, 100 x 81cm
Geneva, Simon Spierer Collection

67 top
The Human Condition, 1935
La condition humaine
Drawing, 56 x 55cm
Courtesy Galerie Isy Brachot, Brussels

67 bottom
Magritte in his studio-salon, 1965
Photo: Georges Thiry, courtesy Yellow Now

68
The Two Mysteries, 1966
Les deux mystères
Oil on canvas, 65 x 80cm
Courtesy Galerie Isy Brachot, Brussels

69 top
Drawing from the "Pour illustrer Magritte" book,
Les Lèvres Nues, April 1970

69 centre
The Philosophical Lamp, 1936
La lampe philosophique

Oil on canvas, 50 x 60cm
Brussels, private collection

69 bottom
The Pipe, 1926
La pipe
Oil on canvas, 26.4 x 40cm
Antwerp, Sylvio Perlstein Collection

70
The Empty Mask, 1928
Le masque vide
Oil on canvas, 73 x 92cm
Düsseldorf, Kunstsammlung Nordrhein-Westfalen

71
The Interpretation of Dreams, 1930
La clé des songes
Oil on canvas, 81 x 60cm
Paris, private collection

72
The Explanation, 1954
L'explication
Oil on canvas, 80 x 60cm
Private collection

73
The Flavour of Tears, 1948
La saveur des larmes
Oil on canvas, 59.5 x 50cm
Brussels, Musées Royaux des Beaux-Arts

74
Collective Invention, 1934
L'invention collective
Oil on canvas, 75 x 116cm
Private collection

75
Pleasure, 1927
Le plaisir
Oil on canvas, 73.5 x 97.5cm
Düsseldorf, Kunstsammlung Nordrhein-Westfalen

76
The Art of Conversation, 1950
L'art de la conversation
Oil on canvas, 65 x 81cm
Private collection

77
The Legend of the Centuries, 1948
La légende des siècles
Gouache, 25 x 20cm
Private collection

78
The Pleasure Principle (Portrait of Edward James), 1937
Le principe du plaisir (Portrait d'Edward James)
Oil on canvas, 79 x 63.5cm
Chichester, Edward James Foundation

79
Study for: The Pleasure Principle (Portrait of Edward James), 1936
Indian ink drawing
Private collection

80
The Discovery of Fire, 1934/35
La découverte du feu
Oil on canvas, 34.6 x 41.6cm
Courtesy Galerie Isy Brachot, Brussels

81
The Cicerone, 1947
Le Cicérone

Oil on canvas, 54 x 65cm
Courtesy Galerie Isy Brachot, Brussels

82 left
Perspective II: Manet's Balcony, 1950
Perspective II: Le balcon de Manet
Oil on canvas, 81 x 60cm
Ghent, Museum van Hedendaagse Kunst

82 right
Edouard Manet:
The balcony, 1868/69
Le balcon
Oil on canvas, 170 x 124.5cm
Paris, Musée d'Orsay

83 left
The Liberator, 1947
Le libérateur
Oil on canvas, 99 x 78.7cm
Los Angeles (CA), Los Angeles County Museum of Art, Gift of William Copley

84
Golconda, 1953
Golconde
Oil on canvas, 81 x 100cm
Houston (TX), Courtesy The Menil Collection

85
The Month of the Grape Harvest, 1959
Le mois des vendanges
Oil on canvas, 130 x 160cm
Private collection

86
The Large Family, 1963
La grande famille
Oil on canvas, 100 x 81cm
Private collection

87
The Voice of the Winds, 1928
La voix des vents
Oil on canvas, 73 x 54cm
Private collection

88
The Labours of Alexander, 1967
Les travaux d'Alexandre
Bronze, 61 x 150 x 110cm
Courtesy Galerie Isy Brachot, Brussels

89
The Seducer, 1953
Le séducteur
Oil on canvas, 38.2 x 46.3cm
Private collection

The publishers would like to thank those museums, galleries, collectors and photographers who have supported them in producing this work. In addition to those persons and institutions cited in the legends to the pictures, the following should also be mentioned:
A.C.L. Brussels (34/35, 43 bottom, 60, 83 right, 91); Ch. Bahier, Ph. Migeat (15 left); Blauel/Gnamm, Artothek (52); Courtesy Galerie Isy Brachot, Brussels (7, 10 top left, 22, 23, 24, 26 bottom, 30 top, 31 left, 36, 48, 49 top, 50, 51, 62, 65 left, 67 top, 68, 80, 81, 88, 90 left, 90 centre, 90 right); The Bridgeman Art Library, London (10 top right, 59); A.C. Cooper Colour Library, London (78); Editions de la Différence, Paris (93 top centre); © Hickey-Robertson, Houston (TX) (8, 55); Kate Keller, © 1981 The Museum of Modern Art, New York (43 top); © 1992 The Museum of Modern Art, New York (14); Photothèque René Magritte – Giraudon (front cover, 9 bottom, 11, 19, 25 left, 27 bottom, 27 top, 28, 42, 46, 47, 49 bottom, 53, 54, 58, 72, 76, 82 left, 85, 87, 89); Photothèque Succession René Magritte, Brussels (2, 9 top, 10 bottom right, 12, 13, 15 right, 16, 17, 25 top, 26 bottom, 29 top, 30 bottom, 31 right, 32/33 top and centre, 38, 39, 44, 45, 56, 57, 61, 63 top left, 63 top right, 63 bottom, 64, 65 right, 66, 73, 74, 77, 86, 93 bottom); Rheinisches Bildarchiv, Cologne (40); © Photo R.M.N. (82 right); Speltdoorn (32/33 bottom); Georges Thiry, Courtesy Yellow Now (67 bottom); G. Westermann, Artothek, Peissenberg (84).

Contents

3.2.1 Living organisms vary and this variation is influenced by genetic and environmental factors

Types of variation

Variation exists in two basic forms:

1 Variation between different species is **interspecific** variation.

2 Variation between members of a species is **intraspecific** variation.

Interspecific variation

The differences between species are largely due to differences in their **DNA**. For example, DNA analysis shows that 98.6% of the DNA sequences found in humans and chimps are the same. The differences between humans and chimps arise because of two factors:

- The structure and sequence of the **genes** in each organism.

- The way in which the genes are **expressed**.

There's an important difference between having genes and expressing them. Humans and chimps may possess very similar genes but some remain unused while others are expressed. A gene can only have an impact on an organism if it is switched on and used to make a particular protein.

Intraspecific variation

Why are we all different? Let's start with two important definitions. The **genotype** of an organism is the genetic makeup, the collection of **alleles** that the organism has inherited from its parents. The **phenotype** of an organism is the collection of observable features that it has.

Why do we turn out the way that we do? There are two possible causes of variation, sometimes referred to as 'nature v nurture'. Is it the genes we have inherited (nature), or are environmental factors important (nurture)? The answer is usually that it's a complex interaction of both.

Essential Notes

Put simply: genotype + environment = phenotype

Types of intraspecific variation

There are two basic types of intraspecific variation, **discontinuous** and **continuous**.

Discontinuous features fall into one category or another. The human ABO blood group system is a classic example. Individuals are either A, B, AB or O – there is nothing in-between. Discontinuous features are usually controlled by single alleles, which the individual either has or does not have. Most of the examples you have studied in genetics at GCSE, such as tongue rolling, feature discontinuous variation.

Features that vary continuously show a whole range of values. In humans most variation is continuous; height, shoe size, intelligence, and so on. For most factors that vary continuously, most individuals fall into the mid range, giving a **normal distribution** (Fig 1). Continuous variation is said to be **polygenic** – it is usually controlled by several genes. This type of variation is often influenced by environmental factors: much more so than discontinuous variation.